The **DESIGNER'S GUIDE** *to*

COLOR

COMBINATIONS

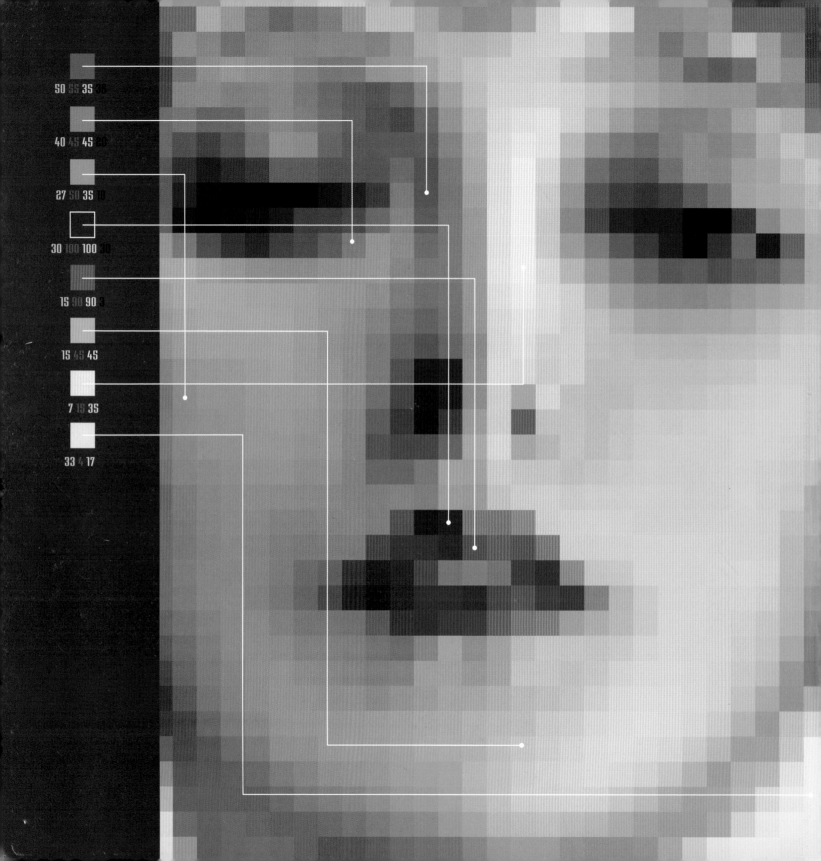

50 55 35 30

40 45 45 20

27 50 35 10

30 100 100 30

15 90 90 3

15 45 45

7 15 35

33 4 17

The DESIGNER'S GUIDE *to*

COLOR

COMBINATIONS

500+ Historic and Modern Color Formulas in CMYK

Written and Designed

by LESLIE CABARGA

*Color layouts by Leslie Cabarga
and Rose Bevans*

NORTH LIGHT BOOKS
CINCINNATI, OHIO

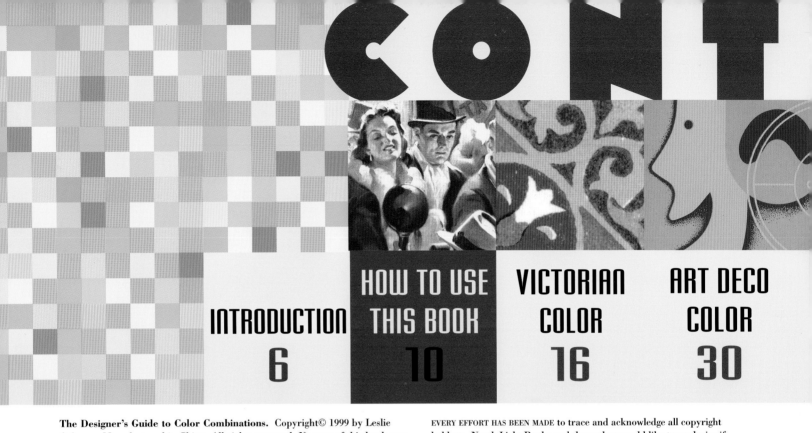

CONT

This hardcover edition of *The Designer's Guide to Color Combinations* features a "self-jacket" that eliminates the need for a separate dust jacket. It provides sturdy protection for your book while it saves paper, trees and energy.

Other fine North Light Books are available from your local bookstore, art supply store or direct from the publisher.

03 02 01 00 5 4 3 2

Library of Congress Cataloging-in-Publication Data

Cabarga, Leslie
 The designer's guide to color combinations / written and designed
 by Leslie Cabarga : color layouts by Leslie Cabarga and Rose Bevans.
 — 1st ed.

 p. cm.

 ISBN 0-89134-857-3 (alk. paper)
 1. Color in art. I. Title.
 NK1548.C23 1999
 701' .85—dc21 98-33482
 CIP

EVERY EFFORT HAS BEEN MADE to trace and acknowledge all copyright holders. North Light Books and the author would like to apologize if any credit omissions have been inadvertently made.

THANKS TO: Rose Bevans for items from her collections of 1950s and 1960s ephemera; to Andrew Schwartz and Janet Klein for items from their collection of late nineteenth-century ephemera; to editor Lynn Haller for her patience and humor throughout this arduous process; and to Marga and Anna for making it all worthwhile.

MANY OF THE DISPLAY TYPE FONTS used throughout this book were designed by the author and are available on the Web by visiting www. lesliecabarga.com.

Edited by Lynn Haller
Cover and interior designed by Leslie Cabarga
Cover illustration by Alphonse Mucha and Leslie Cabarga

Introduction

The libraries and bookstores are filled with scholarly books on color harmony and color theory. Complete with color wheels, and even mathematical calculations, such books attempt to help the artist achieve successful color through foolproof equations.

Surely, the knowledge of such theories can only be helpful, but for many of us in this day and age, without the benefit (or detriment) of an academy course in color theory, our selections ultimately depend upon predilection or personal taste. As an illustrator, I have never consciously chosen an "analogous" color combination or a "triad," and the only "split complements" I've gotten have come from my father. Personal taste in color should not be discounted as frivolous. Our mental selection processes involve millions of gigabytes (in computer terms) worth of conscious and subconscious dreams, emotional memories and other associations of color. We may look at an ad in a magazine and say, "That looks cool!" but our true affinity with the colors we're viewing goes deeper.

A personal method of color selection eschews the intellectual and methodical left-brain approach, which adores "color theory," and moves the process to the right brain, which bases its decisions upon instinct and intuition. This is related to the process currently taking place throughout the world in which

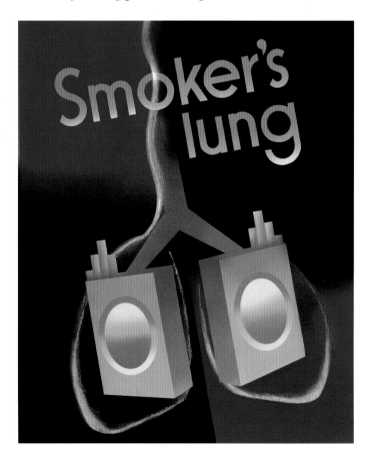

the intellectual/left-brain/masculine approach is, thankfully, beginning to come into balance with the emotional/right-brain/feminine principle.

Another subconscious identification with color comes from the chakra system of energy centers located within our bodies. For example, the root chakra, represented by red, corresponds to the base of the spine and the sexual center. Little wonder that red is often used by artists in connection with sex and Valentine's Day.

In the recently re-emerging art of color therapy, colored lights are applied, in effect, to restore missing tones which can bring harmony back to a sick body. Similarly, the color of the clothing you tend to select often reflects your mood, or may, in turn, affect it. For this reason, it is said that people who habitually wear black probably should not—although that would leave everyone in New York and Los Angeles without a thing to wear.

SMOKER'S LUNG Left: This pharmaceutical illustration was painted by the author in 1990. Above: Four examples demonstrate how a color scheme, as well as elements of an existing design, may be extrapolated for use in a new context. Note the vastly different overall effects achieved through the rearrangement of the very same colors from one example to the next.

That a poor choice of colors affects us subconsciously is a fact observed by many real estate agents. Potential buyers viewing a house with ugly wallpaper will often reject the whole house. I recall as a child not being able to eat in a certain restaurant whose

walls were painted a pale, 1950s green.

But taste in color, like anything else, can be idiosyncratic. Some colors come in shades only their creators could love. Many examples in this book show that the secret of successfully combining a group of colors may have less to do with the colors themselves than with their arrangement within a picture. Occasionally, I have been shocked to notice that the same colors I had used to create an attractive painting looked so awful in their haphazard arrangement on my palette. Therefore, it may be said that colors are only beautiful within the context of their spatial relationships to one another.

As we reach the end of this twentieth century, an artistic reassessment of all that's come before is taking place. While current trends continually evolve and subsequently dominate fashion and design, in today's aesthetic rule book, (almost) anything goes. The styles and colors of every period throughout history seem to be fair game and valid "copy" for today's artists. The concept is king (or queen) in today's world of graphics. Style and color choices often become intrinsic to the concept and are dictated by it. The concept may involve a Victorian mood, or a high-tech look may be appropriate. The first suggests warm, highly saturated, though muted, colors, and the second, cooler colors, perhaps metallic hues, and lots of solid black with an accent of solid red.

And that's where this book comes in. Here are hundreds of cool (and warm) color combinations picked from a variety of sources old and new, and just ripe for the specifying. What makes these combinations valuable is that they are all based upon existing examples created by professionals, some of whom had actual training in color theory—so we don't need any. The work of many well-known artists and designers is presented in this book alongside those whose names have been

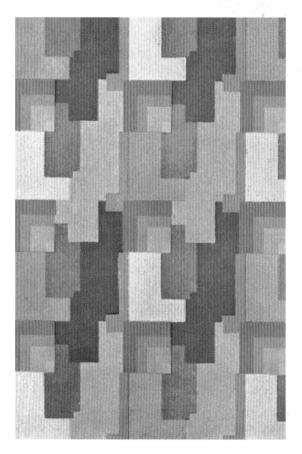

▦ 20 20 20	▦ 70 40 65 30
▦ 5 60 75	▦ 60 35 60 20
▦ 15 75 80	▦ 50 30 60
▦ 15 40 60	

LINOLEUM, 1935 Cool color schemes may be found anywhere, even underfoot, as the sample layout above proves.

CHINA INTERNATIONAL MEDICAL UNIVERSITY PROSPECTUS, 1997
Take one lackluster layout, select a color combination from this book and mix vigorously until beautiful. Serves three or more.

lost in the pages of time but whose work reveals a synchronistic connection with the colorful mood and spirit of their epochs. As is apparent from the color combinations in this book, trends in color throughout specific periods in history are often as easily definable as the more obvious change in hemline length. But there have always existed, within each period, artists who will flout convention and produce designs with unexpected and unusual colors. This sometimes makes grasping the essence of period color difficult. But who cares? Color, then as now, has always been a matter for creative exploration, with the next brilliant inspiration lying somewhere just beyond the rainbow. Whether your next color selection comes from this book or the old linoleum on your kitchen floor—or even, heaven forbid, straight from your own mind—we hope it will be a colorful and harmonious experience!

How To Use This Book

WHEN IT COMES TO COLOR, CONTEXT IS EVERYTHING A little bit of a certain color may make a composition beautiful, while too much of the same color may wreck it. This is why the color combinations shown in this book have been arranged in simple layouts, rather than shown as blocks of equal-sized swatches. Our intention is not only to show nice colors, but to suggest effective proportional relationships of those colors to one another. Yet, as we have suggested in the earlier example, "Smoker's Lung," these relationships of color may still be altered in any way that pleases the user.

HOW THIS BOOK IS ORGANIZED At the top of each page is a reproduction of a piece of art, design or photography that has been selected for its interesting use of color. To the right of the reproduction are two sample layouts with colors extrapolated from it. In the nearest of the two sample layouts, the arrangement of colors approximates as much as possible that of the reproduction piece. The second sample layout demonstrates how changing the positions and emphasis of the colors can completely alter the visual effect of the scheme. Of course, the sample layouts are not intended to be copied exactly, either as to color or design, or to limit the user in any way.

At the bottom of each page are three more sample layouts that I've adapted from other designs. Although these sources are not reproduced in this work, the same attempt has been made to maintain the color relationships as they appeared in the original reference material. In the 1960s section, for example, the bottom-of-page color layouts have all been adapted from authentic 1960s reference: posters, ads, fabric design, etc.

NOTES ON THE NATURE OF COLOR REPRODUCTION The color system used throughout this book is the CMYK (cyan, magenta, yellow, and K for black) process color system known to all printers. Process colors have been formulated to render almost every color in the spectrum through combinations of halftone tints. Although process color does not entirely succeed in this mission, it's currently the best system we have. Many years ago, multicolor printing was accomplished with what printers now call spot colors—that is, colors specially mixed as

10

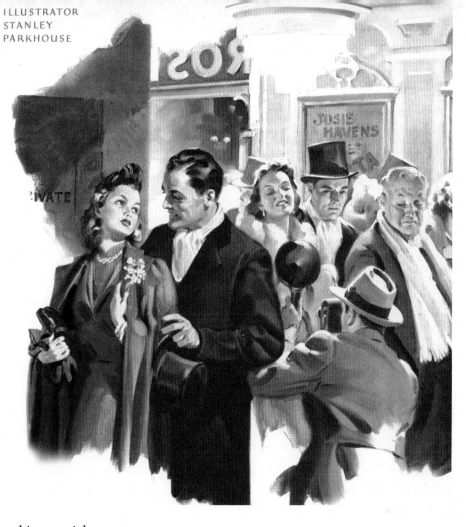

ILLUSTRATOR
STANLEY
PARKHOUSE

STANLEY PARKHOUSE, Magazine Illustration, 1940 In the days when four-color printing was less common than it is now, most popular magazines contained sections featuring two or three colors. Illustrators usually created their paintings in the same limited color combinations from which they were to be reproduced.

required to realize the artist's intention. It wasn't unusual to find print jobs of four, six, eight or even twelve colors then. Examples of such lavish multicolor printing may especially be found in the Victorian Color section of this book.

Where the CMYK system requires a mixture of cyan (blue which contains no yellow or red) and magenta (red without any yellow or blue cast) to achieve a rich, royal blue, the old method would have been to mix the darker blue ink and print it as a fifth color. Before the CMYK system became firmly established, three- and four-color printing was often accomplished with a vermilion red, a royal blue and a golden yellow. The resulting warmer and somewhat darker print quality now looks appealingly nostalgic. In magazines, as in some early motion picture color systems, artwork and photographs were often separated into two colors, such as orange and green, for reproduction. Nowadays, there are scarcely any color separators left who'd even know

how to separate an orange and green painting—into orange and green! In fact, there are scarcely any traditional, nondigital, photographic color separators left, period. I wonder if, in coming years, we will discover that photographic color separations were superior to digital ones just as many sound engineers prefer the now outmoded analog recordings to digital ones.

Most artists agree that process colors by themselves are rather crass and garish looking. Pure cyan, magenta and yellow, unmixed, can look "cheap" and indicate the work of an unsophisticated designer. Such use of color is often found (shudder!) in supermarket house-

brand or generic packaging. Except during the 1960s, when pure process color treatments were purposely used for their eye-disturbing brilliance, the preference has always been to use process colors as mixes. For example, 40% blue and 100% yellow make a nice grass green. But if your intention was to print with such colors you'd save money specifying one spot color mixed to that shade rather than printing two process colors.

The system most printers use for spot color is the Pantone Matching System (PMS), a proprietary system of formulas for achieving a wide spectrum of colored inks (other ink systems are used but not as commonly as Pantone). To achieve the same grass green color, PMS 375 might do the trick. And yet, the standard range of PMS colors is still too limited to adequately match the almost infinite number of CMYK combinations. In many years of buying printing, I almost never found a PMS color that was close enough to what I wanted. That's why CMYK formulas are provided in this book but not Pantone colors.

On The Necessity Of Mixing Colors "Never use colors straight out of the tube" has long been a painters' axiom. Paint pigments are most often mixed together, not only to avoid a superficial or crass appearance, but for consistency, texture and opacity. The same rule applies to CMYK inks. Our grass green mixture resulting from 40% cyan and 100% yellow may be nice, but try adding 10% K (black) or 20% magenta and it becomes simply sumptuous! Complex mixtures of process inks give many of our historic color schemes their special appeal. Pantone colors are too often of the "out of the tube" variety. They are simply too bright and vulgar.

Most of the color formulas in this book are given as percentages in increments of five or ten, such as 30% or 45%. When necessary, we've used numbers like 13%. In the days when printers laboriously laid combinations of halftone screens over film negatives to achieve the tints specified by designers, screen increments of 10% were all that were available. Today, with computers, a designer may effortlessly specify a halftone percentage such as 37.354% if she desires it. Never before in history has the designer had such flexibility, not only in applying crazy percentages of halftones, but in testing color combinations.

It used to take hours with markers, colored pencils or paints to dummy up several alternate color versions of a design. With a computer, we designers are able to change one or all of the colors in our jobs instantly and note the result. I believe that the unusual and exciting color combinations that have begun to appear in recent years are the result of computers allowing for trial and error. It is a marvelous time to be a designer (except when your hard drive crashes and you forgot to save your work).

I believe that the value of this book lies not just in the hundreds of attractive and viable color combinations provided along with CMYK equivalents. The true value comes from the learned ability to adapt colors in the manner demonstrated. The user of this book will learn to pluck color schemes from the unlikeliest places, much as the syndicated cartoonist learns to grab his daily gag from even the most innocuous of dinnertime remarks. This technique makes the whole world our color palette. Color schemes can be derived (OK—*ripped off*) from graphic or fabric designs, from photographs or a small area within a photograph. Color inspiration may come

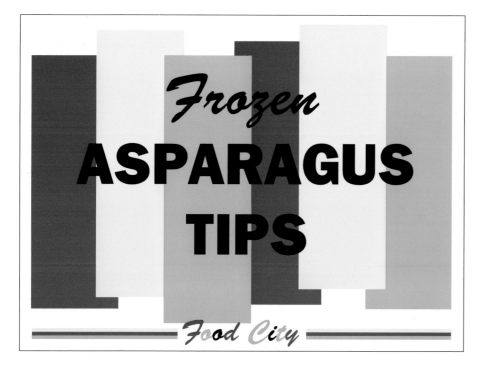

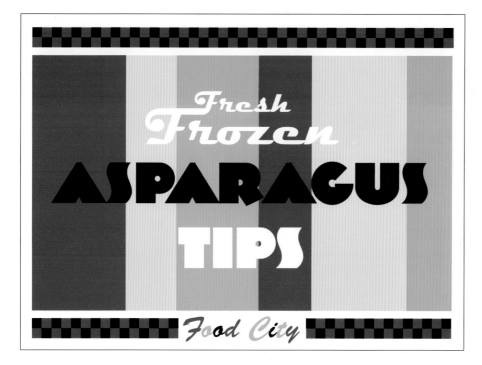

ASPARAGUS TIPS Left: This 1960s can label in unmitigated process colors looks unappetizing. The designer of this label was so behind the times, he even used Franklin Gothic for the main display font instead of Helvetica. The designer surprinted the type in 100% black but did not add a back-up layer in a tint of blue which would have prevented the colors underneath from showing through.

I was asked by Moe, the owner of Food City, to design a new label—not that there was anything wrong (in his opinion) with the old one, but he had run out of 'em. I updated the type fonts (backdating them, actually), inserted a checkered border (because I asked myself, "What would Milton Glaser have done?") and created more interesting colors by adding other tints to the previously all-solid process colors. The label colors now have much more subtlety and depth. Unfortunately, Moe would not let me change that awful Food City logo.

from architecture and nature, such as the subdued tones of an Art Deco terra-cotta frieze or the variegated hues in a single flower petal.

A TALE OF COLOR REPRODUCTION As an illustrator and author, my work has been almost continually in print in some form, somewhere, every day since 1970. And yet, I have rarely felt satisfied with the fidelity of color reproduction by any printer. There is always a color shift. When we look at a book of great old posters, we are

BAD COLOR, BAD VALUES In this "anything goes" era of computer color, we find old principles and prejudices rapidly falling away. What, then, if anything, constitutes a bad color scheme? In the examples above, the values of the colors are too close together, and do not span a great enough range to be dynamic or to "read" well. This is proven by converting the colors to grayscale. Color schemes like these may still seem eye-pleasing, however, and a number of them may be found in this book, especially in the chapter on 1960s color.

actually looking at many stages in the garbling of color.

Let's consider a typical, though hypothetical, history of color shifting: Back in 1899, an artist had a poster printed. When he saw the finished result he shook his head and muttered something like, "*Sacrebleu!*" The colors had shifted slightly from his original vision of them. Years later, in 1959, someone found a copy of that poster and photographed it for reproduction. By then, the poster's inks had faded and the paper had yellowed. There was a shift in color in the photographer's transparency due to the color of his lights and the particular emulsion of his film. By the time the printer had made a color separation from the transparency, you can bet the colors had shifted again. When the poster was reproduced (by letterpress, which probably resulted in an oversaturation of the black plate) in a book about old posters, the colors again were altered. Not only that, but from the time the presses began their run to the time they finished printing, the saturation and coverage, as well as the registration of the four-color process inks, had varied several degrees.

Well, that fine poster book, its pages yellowing, remained in a used bookshop for many years before it was purchased in 1989 by a hot-shot young designer with the latest model Macintosh, complete with a desktop scanner. That designer (who might have been me, or you!) scanned the old poster and noted that the colors had changed radically from how they looked in the book. Of course, what the designer saw through the red, green and blue filters of his video monitor was far from a true representation of the way the image would look when it was again reprinted. After some adjustments using a curves filter, the designer placed the image of the poster into his layout and sent it to the

GOOD VALUES, GOOD COLOR Top right and center right: Two examples of successful color schemes which remain crisp and enticing even when converted to grayscale. A wide range of values is displayed here from solid black, or almost black, to pure white, or virtual white. Bottom right: Another means by which color may nonsubjectively be deemed good or bad is by determining its appropriateness to the subject matter to which it has been applied.

printer where, once again, due to over- and/or under-inking, dot gain, paper color, etc., the colors shifted. And then the designer's finished piece, a four-color, gang-run rave party announcement, lay for three weeks in the window of a record shop where it faded somewhat in the sun. And at that same moment, far away, something else shifted—in the Père Lachaise cemetery, six feet below Paris, the original poster artist turned 180 degrees in his grave.

All of this is by way of suggesting to you, the user of this book, to do your best to choose the colors you want, but don't obsess over them. There will always be a color shift, and more often than not, you will be the only one who notices.

SOMETHING BORROWED, SOMETHING SWIPED It has been said that "he is most original who borrows from the greatest number of sources." Let this become your watchword, whether in creating concepts or color schemes. Even Michelangelo's earliest works were rip-offs of classical Greek statuary (I'm told he was being guided by the spirits of those Greek sculptors). Copying is simply a way one can learn. It is impossible for one artist to call forth from memory the infinite number of color schemes she may find by looking through just one design annual. . . or by simply going for a walk.

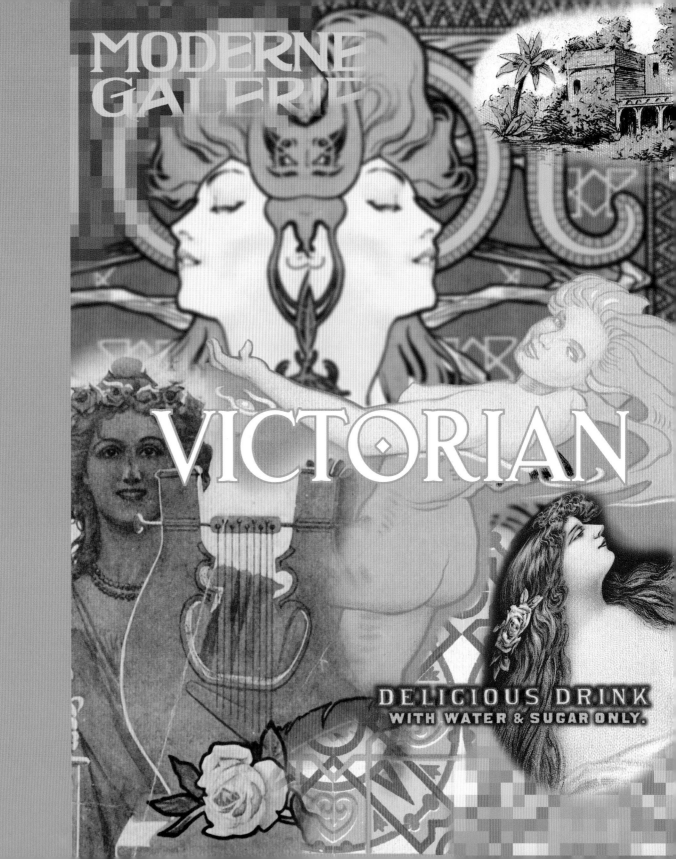

MODERNE GALERIE

VICTORIAN

DELICIOUS DRINK
WITH WATER & SUGAR ONLY.

Golden oak and dark walnut woodwork; maroon and forest green draperies.... Colors like these, which seem to have been lifted from somber, old-master paintings, gave the Victorian era its nickname: the Brown Decades. The Victorian period was actually a long one, lasting from 1837 through and beyond the year 1901 when the old queen died. It encompassed many different styles and fads, but we are concerning ourselves mainly with the late 1880s and 1890s. ◆ In these years, the three primaries—red, yellow and blue—were typically mixed as yellow ochre, brick red and slate blue. One reason was the technology of pigments available at the

time; another was due purely to predilection. Although the Victorians often introduced quite garish accents to their color schemes, no doubt the fainting couch would have become even more popular if they could have glimpsed our modern process colors and Day–Glo fluorescent inks. ◆ In the Victorian era, color printing was generally accomplished with a greater number of inks than are used in our current four-color system. A piece of art intended for reproduction was assessed as to its most important colors and then as many inks as necessary (and could be afforded) were accordingly selected. ◆ It was felt that a color range should be closely stepped from light to dark, avoiding any sudden jumps in value. The result was a deep, dark modulation of rich, warm tones. ◆ Several of our examples in this chapter are Art Nouveau pieces designed approximately within the same time period as the Victorian work. Art Nouveau developed in France as a nature-inspired, handicraft-driven antidote to industrialization and stodgy Victorian tastes. Not surprisingly, a similar mood of color is present in both styles. Still, the Art Nouveau style introduced a few "startling" new colors, such as emerald, ruby and violet, to the standard palette of the day. ◆ By the early 1900s, the "Colonial Revival" overtook the Victorian style and millions of board feet of ornately carved golden oak were, sadly, painted over in white, lead-based enamel.

RAND AVERY PRINTING COMPANY, 1900 *This design, produced as a self-advertisement by a printer, is as typical of the Victorian era as one can imagine. Painted or inlaid wood paneling is suggested, or possibly tile. Setting off the vivid red and black are the two tones of brown that point to an unofficial Victorian color axiom that no single color shall stand too far apart in value from its neighbors. The interlocking arrangement of the monogram is typical of the period.*

90 100 ☐ WHITE

15 35 60 3

30 55 100 **30**

40 100

VARIATION

10 35 **25** **40 100**

35 60 5

3 30 10

10 80 40

5 25 10 40 25 80

50 15 20 85 75 **35**

22 45

65 90

50 5 10 **100 10 20**

25 95 **15**

90 100 100 **30**

20 40 100 **35**

TARRANT'S SELTZER, c. 1898 *Long before the hippies, followers of the Aesthetic movement were poked fun at by the Victorians, as in this trade card advertisement. Aside from the usual deep greens and reds, the brilliant orange of the sunflower (a symbol of this movement) strikes the dominant note. Whether the lass's transformation was due to a stern father's upbraiding, cult deprogramming or, indeed, the work of Tarrant's Seltzer, we'll never know.*

VARIATION

3 50 90
35 85 50 35
6 20 50 2
65 30 90 45
30 65 35 10
60 55 80
30 10 7

65 35 15
90 100
35 100
70
10 35
40 100

10 35
10 40 70
10 35 25
75 80 100

5 100
90 50 30
70 100 10
40 100
WHITE

19

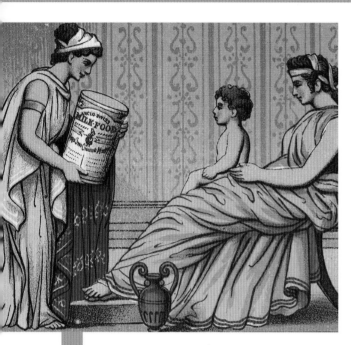

GRECIAN MILKFOOD, c. 1890 *To the creators of this early infant formula, the Greek motif obviously outclassed the plain milk of mother's breast. The colors in this design accentuate the three primaries, making it appear as though the infant Kal-el is about to be sent off to Earth from the dying planet Krypton. The interesting color note here is the fleshy-tan wallpaper.*

15 93 100 **3**
15 30 90 **3**
30 75 100 **35**
25 55 70 **15**
45 10 25
10 35 40

VARIATION

80 100 100 **30** 3 15
70 100 **10**
10 100 15
50 100 **10**

90 70 **10** 10 20
35 70 **10**
35 100 75 **20**
30 45 45

4 35 15
55
30 35 70
75 25 35
100 50 **10**
□ WHITE

JAPANESE SOAP, 1875 *The Victorians held a fascination for exotic cultures, whether Egyptian, Greek, Chinese or Japanese. Any superficial resemblance to a Japanese color scheme in this design must have been purely occidental. I like the way in which the tea-house in the background has been de-emphasized by limiting the colors of its delineation to red and blue, eschewing the available darker brown and black inks.*

VARIATION

10 33 70	23 75 85 5
8 95 100	50 20 75 15
50 15 35 5	WHITE
35 65 55 50	

25 80	10 35 3
10 25 50	65 65 15
10 100 30	40 100
70 80 30	

30 20 50	10 40 60
5 5 20	20 65 65
40 50 15	40 100
20 25 10	

100 5 10 40
5 10 20
15 15 3
40 60 35

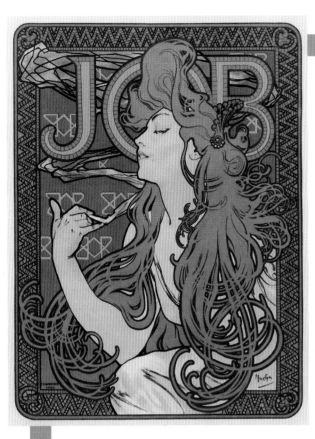

JOB, Alphonse Mucha, 1898 *Mucha is to Art Nouveau what Disney is to animation. Mucha's posters set the pace for all other Art Nouveau graphics. He gets an A+ just for the signature twirling hair, which no artist since has ever been able to duplicate so rhythmically. I believe that the key to "great" art, both "fine" and "commercial," is an excellent design and composition. Mucha was an expert in that regard along with his fine drawing skills and great color sense.*

VARIATION

50 15 70 3 20 15 10
20 50 80 15 5 10 20
7 30 50 40 100
35 65 37 25

15 100 40 20 10 15
5 25 3 20 100 10
60 20 10 35
60 80 10

30 30 50 15 25 20
85 85
15 25
35 50

65 30 30 35 40 15
15 75 8 40 100
20 25 60 5
10 10 35

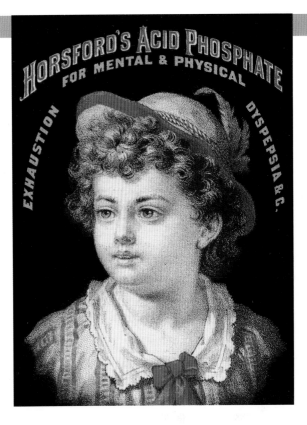

HORSFORD'S ACID PHOSPHATE, c. 1899 *The black background gives this advertisement its punch. The slightly muddied, though still brilliant, red and the warm gray (rather than the expected pure white) give this piece its Victorian flavor. The art is a wood engraving, typical of the period. Dyspepsia, from which the word "pep" derives, simply means poor digestion, and this phosphate drink was nothing more than what would today be called soda pop.*

10 15 25 **2**
30 20 40 **13**
8 90 100 **3**
40 100

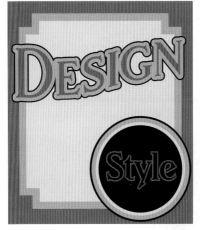

VARIATION

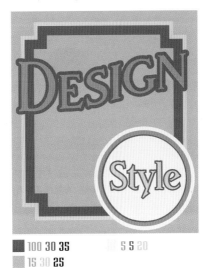

100 30 35 5 5 20
15 30 **25**
10 100 **5**
60 80 **5**

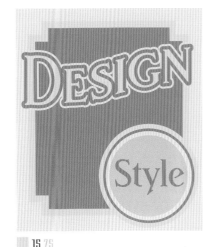

70 30 **35** 10 10 35
40 70 **20** 10 65 70
50 75 75
10 20 100

15 75
70 70 **5**
15 30
25 25 **10**

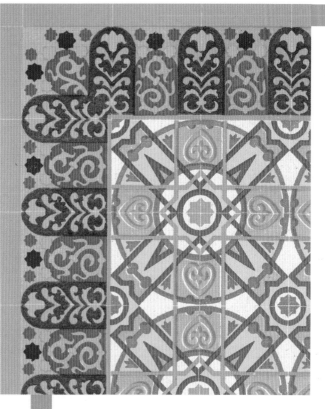

BARCELONA TILE, 1903 *Tiled floors such as this one may still be found in Spain and Cuba, where such tiles were imported. The arrangement of the tiles provided a plain perimeter border that could be extended to the walls, a fancy border and an interior field. The fancy border is in laid-back colors with darker values, while the interior field is brighter to set itself apart and define the area of its setting. This image comes from a manufacturer's catalog.*

25 30 50	4 8 20
20 60 100	50 40 80 30
25 8 75	10 85 95
4 45 65	

VARIATION

100 20 40
15 75
80 100
10 10 35

10 30 100	40 100
50 100	
10 15 35	
50 40 100 30	

100 40 30	30 100 70 30
85 70 45	
15 70	
70 65	

MERMAID, Leo Putz, c. 1900 *In Germany, where this lovely print originated, the Art Nouveau style was never as flamboyant as in France. Yet the flowing hair betrays the picture's roots in the Art Nouveau style. Nowadays, we would design this as a black and yellow duotone, but Leo Putz's deceptively monochromatic treatment with subtle interplay of cool-warm and warm-cool tones creates a luscious undersea ambience.*

5 7 35
40 30 70 10
37 45 100 30
25 10 45

4 15
60 70 75 60
27 20 60

VARIATION

30 40
55
20 15 35 10
65 70

40 100

85 85
10 65 70 30
20 75 80
20 30

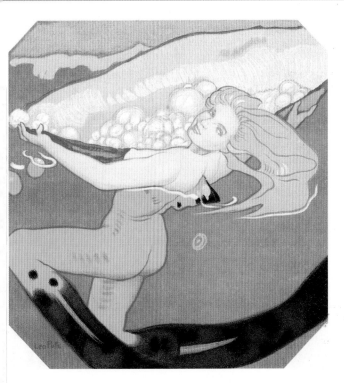

10 30 100
60 100 40
5 5 20 5
15 60

40 100

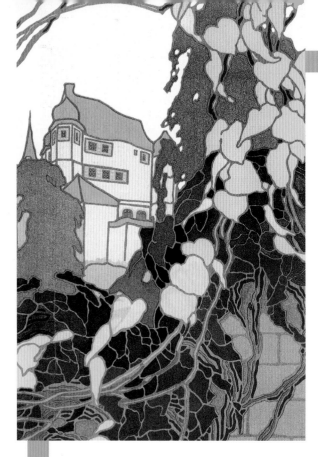

DECORATIVE PRINT, Franz Waldraff, 1900 *This stunning design was printed in Stuttgart on a gray paper stock with at least eight ink colors, some of them opaque. It was part of a swipe file portfolio intended as inspiration for architects and designers. The rich, warm foliage colors in the foreground create a nice contrast with the lighter-toned colors of the house. As a background, the common influence of the gray paper helped to unite the various ink colors.*

■ 25 70 90 35	■ 35 35 100 35
25	■ 20 55 80
25 95	■ 30 45 65 4
35 20 80 3	

VARIATION

■ 30 35 25	■ 50 30 5
35 10	40 50 5
■ 20 70 75 35	
5 25 3	

■ 30 35 25	10 3 10
■ 20 70 75 35	30 60 10
■ 85 85 10	
30 70 35	

30 10 5 20	■ 85 85 10
10 10 50	■ 40 100
30 70	
10 35 15 25	

DECORATIVE PATTERN, V. Mink, 1900 *Huge portfolios of images like this, which may be called the original clip art, were widely produced in Europe. This design represents the German version of Art Nouveau, which was more geometrically and symmetrically inclined than the often unruly French, Belgian, British and Spanish versions. The German Art Nouveau colors were also often cooler, as seen in this interesting and unexpected scheme.*

20 35 30 10	100 63 15 35
53 5 55	WHITE
90 100	
15 65 90 20	

VARIATION

25 10 10	10 40 100
70 80 100	
15 50 5	
30 60 15	

10 50 100	10 50
10 15 35	20 40
30 40 70 20	
5 75 25	

85 80 15	20 80 60 30
45 50	30 30 50 5
30 50 60 20	
5 20	

BARCELONA TILE, c. 1903 *Another floor tile arrangement from Spain. The combination of colors gives a soft dewy effect, like a warm spring morning. Matte finished tiles of this sort usually had printed-on patterns which, after many years, would begin to show signs of wearing in heavily trafficked areas. Nonetheless, such floors create a clean, light, open feeling and are a delight to tread upon.*

30 25 60 5	5 45 100
35 85 100 7	50 50 100 30
20 10 55	
10 4 20	

VARIATION

40 30 70 10	40 25 5
55 25 100 35	70 90 100
20 45 5	
35 10 25	

70 25 5 30	30 40 30 25
40 70 40 10	10 5 20
20 20 25 10	
10 30 70	

10 40 50 20	5 15 3
25 40	40 100
75 80 10	
30 70	

MINTON TILE, 1872 *The innovations of Herbert Minton's Minton & Co. in England led the way to modern tile production. The company's wares are still well-represented in cathedrals, commercial buildings and homes throughout Great Britain and elsewhere. This illustration of a nine-inch wall or hearth tile comes from a Minton catalog. The colors used in this tile design are unsubtle, almost garish, but still sophisticated and in themselves harmoniously combined.*

VARIATION

5 90 100
5 35 75
85 20 65 13
100 70
50 35
40 13 35 3
WHITE

70 25 5 30
100 80 40
20 20 25 10
25 80 5
30 40 30 25
10 5 20

30 35 5
15 5 3
65 65 5
20 25 60 25

5 20 10
50 45
45 25 100 30
40 20 25
20 20 30
20 20

TWINS

ART DECO

1925 to 1939

The Art Deco style had an enormous impact upon the world. *It swept off the European continent in 1925 and eventually, like the tornados that ravaged the American "dust bowl" during the Depression, engulfed everything in its path.* ◆ *Art Deco became the new broom sweeping clean the rusty remnants of the nineteenth century industrial age, which was more concerned with just getting machines up and running than with such frivolous matters as design of a motor housing.* ◆ *If ever a style of design was to provide an antidote to an econom-*

ic depression, Art Deco was that style. Deco's clean, flowing lines were inspired by the emerging science of aerodynamics, the new streamlined sans serif typography from Europe (it's hard now to imagine that there was a time when sans serif type was virtually unknown), and even archeological discoveries in Egypt and South America. ◆ *If the second and third decades of the century favored a fat and friendly, boom-time warm-and-hot palette, Art Deco color was decidedly air-conditioned. So-called Depression green, a mildly nauseating light green, suggested the fiscal conservativism and cautious optimism that symbolized the era. The most specifically Art Deco colors were often drawn from the gray and metallic hues of streamlined chassis, the blues of…the blues and jazz, and other cold pastel tones. And yet, like the colors of any other era, there was a great deal of eclecticism too.* ◆ *Perhaps the best indication of Art Deco's importance is the fact that the Deco revival that began in the late 1960s still shows no sign of abating.* ◆ *Despite many other concurrently popular trends in design, this revival has outlasted the period of Deco's initial reign.*

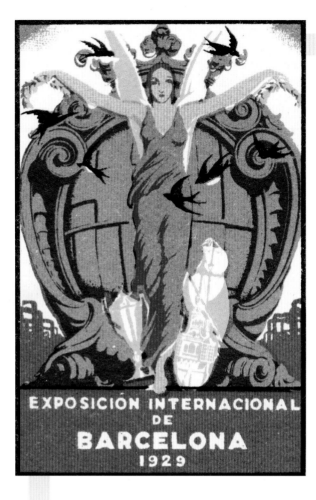

BARCELONA, 1929 *That this tiny poster stamp (shown here more than twice its original size) was originally printed in seven ink colors says much about the time and place in which it was published. Although the registration on this copy is imperfect, the care and craftsmanship is otherwise evident. The color scheme is somewhat warmer than a typical American Art Deco arrangement, though wholly consistent with the Spanish sensibility of this era.*

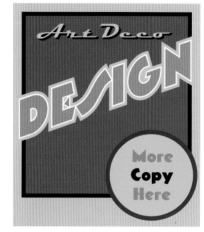

VARIATION

65 50	10 65 100
100 100	10 30 55
55 45	40 100
25 90 100 10	WHITE

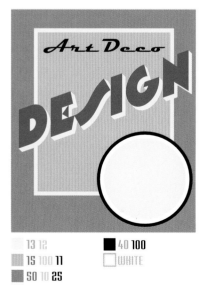

13 12	40 100
15 100 11	WHITE
50 10 25	
15 100 30	

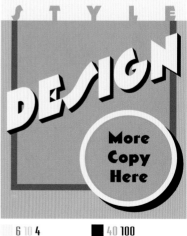

6 10 4	40 100
10 50 10	
30 15 80 10	
100 60 15	

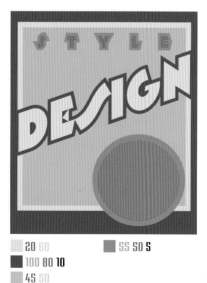

20 60	55 50 5
100 80 10	
45 50	
7 80 100	

THE DAY YOU CAME ALONG, 1934 *This two-color sheet music cover is interesting not only for its weird yet appealing color scheme, but also for the way the purple ink overprints the solid Depression green. This overprinting lends a wonderful effect to the photograph of a young Bing Crosby, the king of the Deco-era crooners. Our samples below liven things up by adding white and black.*

VARIATION

20 32 5
35 80 30 20
40 100
WHITE

70 WHITE
30 20 3
35 75 20
40 100

35 90 60 20 WHITE
85 100 7
70 20 40 5
40 100

10 70 5
40 40 50
65 30 20
40 100

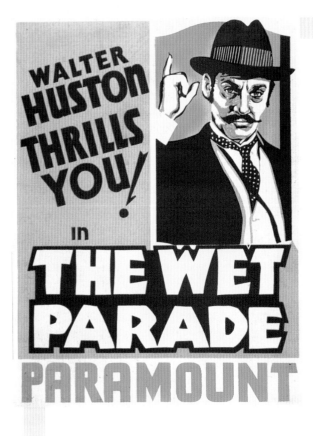

THE WET PARADE, 1929 *One of hundreds of silkscreened designs commissioned by individual theaters as lobby cards during the 1920s and 1930s, this poster's relationship to the Art Deco style lies more in its hand lettering and its "posterized" treatment of Huston's face than in its color scheme. Nevertheless, the colors are rich and compelling, and surprisingly not so out of step with present color trends.*

- 5 20 100
- 5 3 20
- 30 95 95 30
- 50 20 40 5

VARIATION

30 12	WHITE
15 30 80 20	
25 25	
50 100	

- 7 5 15
- 40 25
- 30 55 60 15
- 50 100

30 80	WHITE
50 100	
15 40 60 20	
50 100	

34

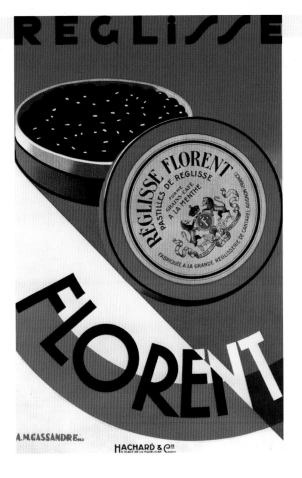

REGLISSE FLORENT, A. M. Cassandre, 1928 *The colors of the French flag are evoked in this bold, geometric poster design. The complexity of the blue-gray product label contrasts with the simplicity of the rest of the design. Cassandre, the premier poster artist of France during the 1930s, worked feverishly on his compositions and was known for his brilliant use of color.*

7 5 10
7 90 100
100 85 70 6
40 25 25 7

■ 40 100

VARIATION

40 40
80 100 15
20 40
■ 40 100

☐ WHITE

40 40
80 100 15
20 60
■ 40 100

15 30 30

80 30 10
30 30 5
10 30
70 60 5

■ 40 100

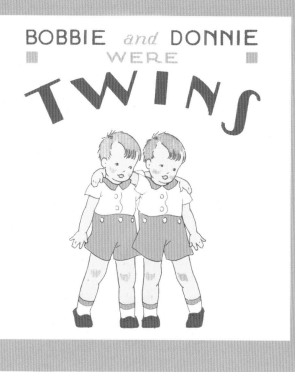

BOBBIE AND DONNIE WERE TWINS, Esther Brann, 1933 *This title page from a children's book reminds us that wonderful effects can be achieved when process cyan, magenta and yellow are replaced with custom ink colors. The powder blue seen here is especially sumptuous. The fuller potential of this arrangement is shown in a third layout at the bottom right of this page, in which the powder blue, pale yellow and fire-engine red are mixed to create maroon and green.*

3 90 100 3 30 55
40 25 5
8 55
5

VARIATION

35 7 3 100
55 10 5 40 35
80 15 7 40 100
100 20 20

25 75 40 100
50 90 6
40 30 5
5 70 25

8 55 20 100 70 30
40 40 15 40 45 5
40 26 5
2 90 100

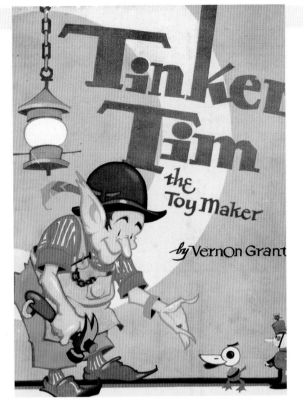

TINKER TIM, Vernon Grant, 1934 *Grant was the creator of the cereal characters Snap, Crackle and Pop. His work could be seen in numerous books and on the covers of such magazines as Colliers, Liberty, and The Saturday Evening Post. In this cover, typical of his approach, Grant mixes a masterful mélange of muted middle tones, then startles us with bold accents of vermilion, golden yellow and sky blue.*

VARIATION

80 20 60 30	25 90 100 30
30 15 50	10 45
4 35 25	75 20 15 5
3 85 75	3 85

50 15	25 75 85 30
100 30 15	20 70 10
30 25 4	12 15
50 90 5	

25 35 5	40 100
100 17	
60 5 4	
3 15	

50 20 100	15 60
20 20 50 5	40 100
20 70 50	
7 30	

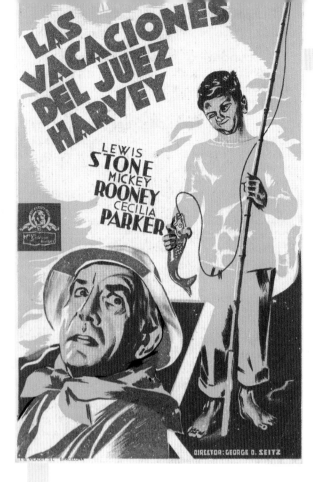

LAS VACACIONES DEL JUEZ HARVEY, 1938 *Reincarnated for Spanish-speaking audiences, this Mickey Rooney film, "You're Only Young Once," gained a new poster design in addition to its new title. The color combination is unusual but appealing. Perhaps it was more common to the eyes of the Spanish audiences for whom the poster was intended. For me, this color scheme is akin to an unexpectedly augmented chord in a musical composition.*

90 60 5 5	45 3 65
5 20	
5 30 60	
25 75 100 35	

VARIATION

5 34 2	40 100
30 25 12	40 100
70 50 30	
30 75 60 10	

100 6	40 100
8 7	
100 20 25 30	
70 85	

60 100	3 10
100 65 10 6	30 55
50 70 10	
30 30 5	

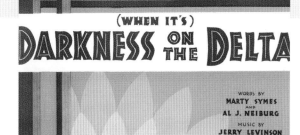

DARKNESS ON THE DELTA, Leff, 1927 *The rectangular panel in this two-color sheet-music cover was designed to hold photos of the various artists, such as Mildred Bailey, who performed the title song. The color scheme suggests the warmth and appeal of the sultry Mississippi River Delta. The two ink colors have been used both full strength and in halftone to extend their range. In the examples below we've mimicked these reduced tints in CMYK.*

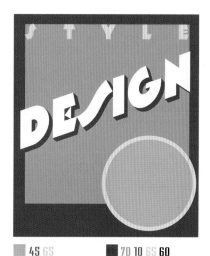

▮ 45 65	▮ 70 10 65 60
▯ 30 45	▢ WHITE
▯ 20 35	
▮ 50 10 50 15	

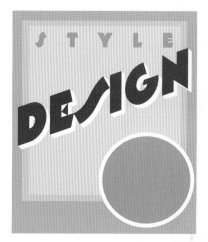

VARIATION

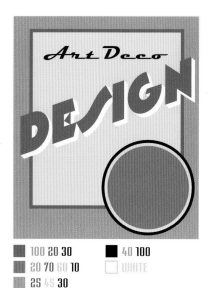

▮ 100 20 30	▮ 40 100
▮ 20 70 60 10	▢ WHITE
▮ 25 45 30	
▯ 15 90	

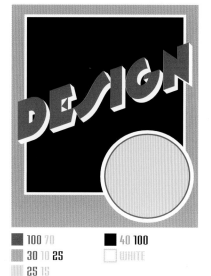

▮ 100 70	▮ 40 100
▮ 30 10 25	▢ WHITE
▮ 25 15	
▯ 7 26	

▮ 60 100	▮ 50 70 30
▮ 50 25 30	
▮ 20 100	
▯ 30 20	

WALLPAPER, 1924 *The first thing you do when you buy an old house is rip out wallpaper like this. The homey design and warm colors (predating the 1980s mauve revolution) are OK, but in the past sixty years, the bathroom upstairs had leaked once or twice, ruining a section of it. Unlike the French and Germans, Americans never embraced Art Deco for wallpaper designs. Cozy stuff like this was about all that was available throughout the 1930s.*

VARIATION

30 80 65 5	30 80 65 5
2 50 45	45 30 70
5 3 25	6 30 60
25 40 45 4	40 100

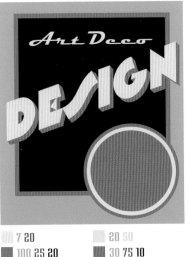

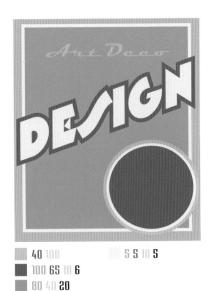

7 20	20 50
100 25 20	30 75 10
70 15	
40 100	

50 10 15
5 50
40 100

40 100	5 5 10 5
100 65 10 6	
80 40 20	
10 30 60 10	

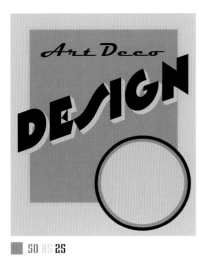

LINOLEUM, 1935 *Through the miracle of linoleum, something resembling a Navajo carpet has been created here. You'd want to rip this out of your old house too, except it would have been laid with black tar, ruining the maple underflooring. The color scheme blends warm, woody tones with some Depression green thrown in for a modern appeal. Can't you imagine Constance Bennett sprawled over such linoleum in the den of her Spanish-style Hollywood home?*

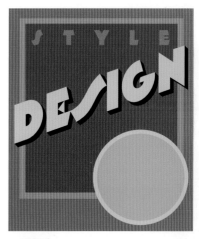

VARIATION

20 35 35
20 55 65
75 100
50 5 55

65 7 65 10
20 93 100
35 90 100 35
40 100

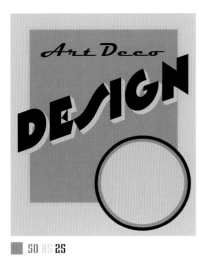

50 85 25
25 15 20 9
10 20 17
40 100

85 85 35
45 30 25
10 25
40 100

WHITE

50 30
50 25 30
85 45
10 80

40 100

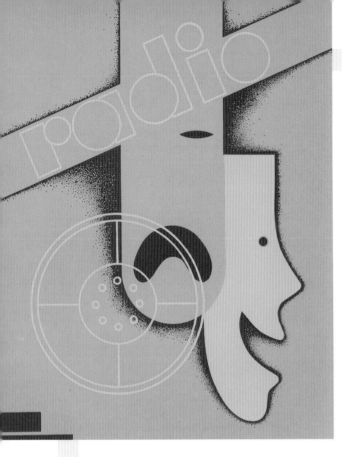

RADIO, 1935 *This brochure cover was actually part of a sample package demonstrating a paper manufacturer's wares. The green background is the color of the paper stock itself. An opaque ink was necessary for the chartreuse green to appear at its brightest. The design puts a Deco spin on the standard comedy/tragedy mask motif and adds some unique hand lettering that could only have been devised during the 1930s.*

75 3 50		
35 10 95		
95 90 5		

VARIATION

70 35 10 25		40 100
35 60 5		
90 100 20		
10 40		

65 90	WHITE
100 90 40	
65 70	
40 100	

70 40
10 100 30
5 10 3
40 100

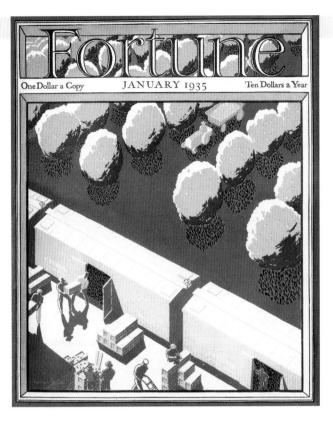

FORTUNE, 1935 *At a time when magazines typically sold for a quarter, you'd have needed a fortune to buy this one. At least Fortune's printing was lavish and its choice of cover artists was superb. Like those of* The New Yorker, *the covers of* Fortune *all matched a certain editorial mood: the wheels of progress were shown turning in somber tones appropriate to the difficult times most Americans (aside from* Fortune's *readers) faced.*

■ 30 15 75 **7** ■ 60 20 60 **65**

■ 25 60 70 **40**

▢ 5 75

▢ 3 20

VARIATION

■ 60 80 **5**

■ 70 90 100

▢ 50

■ 100 90 **20**

■ 30 60 100 ■ 40 100

■ 60 5 15

■ 50 30 100 30

▢ WHITE

▢ 85

■ 50 35 30

▢ 10 5

■ 40 100

43

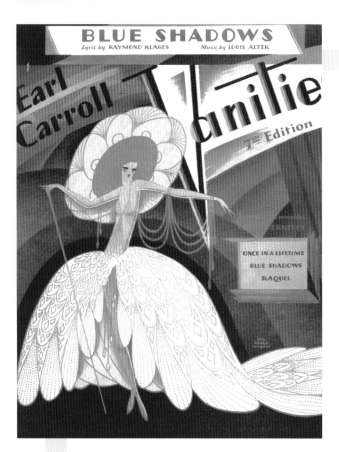

BLUE SHADOWS, 1929 *Like most sheet-music covers, this one was a two-color job. And, like most sheet-music covers of the era, it is a masterful example of the range that can be achieved despite such a limited palette. The use of gradating tones of colors, alone or in combination, is a standard Deco design trick. The surprinting of both colors at full strength achieves a passable "black" and adds depth to the piece.*

▨ 40	▨ 90 55
▨ 5 95	▨ 70 40
■ 60 80 65	☐ WHITE
▨ 60 90 15	

VARIATION

▨ 25 15	☐ WHITE
▨ 15 30 80 27	
▨ 25 25	
■ 40 100	

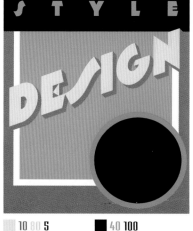

▨ 10 80 5	■ 40 100
▨ 100 40 10	☐ WHITE
▨ 30 60	
▨ 5 60 65	

▨ 10 85 5	
▨ 70 60 8	
▨ 13 30 13	
☐ WHITE	

BEAU RIVAGE, c. 1947 *This luggage label design was produced too late to really be considered Deco, and yet it represents the transition of the style into the 1950s era which, in Europe especially, seemed to lose favor less quickly than in America. Note the bold simplicity of the design. The textured shading on the sails contrasts with the otherwise exclusive use of flat tones. The color scheme is suitably cold in reflection of the so-called cold war period.*

VARIATION

3 45 40 2	30 90 100 40
95 80 30 15	40 100
85 95	WHITE
35 15 10 3	

80 40 30	40 100
12	23 4 25
30 25 45 5	
50 90 15	

25 60 8	
100 30 30	
50 20 30	
15 15	

80 5 15 30	60 80 5
20 20 35 5	
6 6 10 2	
100 70 15 15	

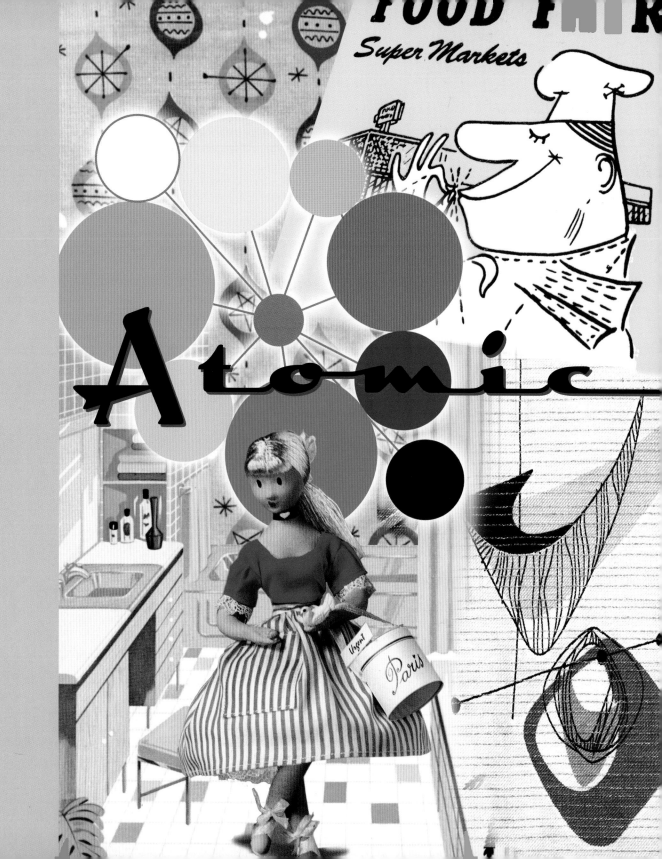

Just as 1930s design took its cue from the expansion of mass production, *the 1950s was inspired by an even more wondrous scientific age that produced the splitting of the atom.* ◆ *Colors like chartreuse and flame red were often chosen*

Age COLOR

for the popular molecule motif used on everything from textiles, ceramic tiles, countless logos and trademarks, as well as in architectural design. ◆ *Following four years of war, during which color schemes in America ran almost exclusively to red, white and blue, or to dreary browns and grayed-down hues (by 1948 almost suffocatingly so), the new 1950s colors were a real pick-me-up. Never mind if their inspiration came from the atomic annihilation of whole cities filled with innocent civilians.* ◆ *Bright pink washing machines beckoned women home from the wartime factories, promising an easier wash day with the many new synthetic, drip-dry fabrics. Blue-green poodles adorned everything from ashtrays to circle skirts, amusing us with rhinestone eyes that echoed our uplifted spirits.* ◆ *Sea-foam green walls entertained pink and turquoise curtains with bacteria-like designs stolen, apparently, out from under a microscope's eyepiece. Nearby, a red fiberglass lamp shade rested atop a salmon-pink ballerina perched on a blond wood kidney-shaped table.* ◆ *The 1950s blasted the nuclear family out of its wartime doldrums into a future that, by the 1960s, would produce still more vivid color combinations.*

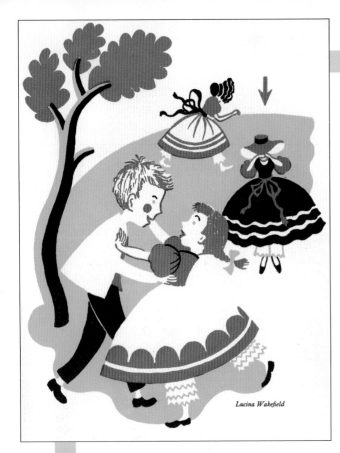

Lucina Wakefield

CALENDAR ILLUSTRATION, Lucina Wakefield, 1956 *For over fifty years, the Marchbanks Press of New York issued monthly self-promotional calendar pieces featuring popular illustrators like Wakefield. The old-fashioned hoop skirts in this one seem to suggest the full poodle skirts of the 1950s. Because the blue is similar to pure cyan, there's no hint of an American flag theme.*

■ 12 95 60
■ 75 6 20
 4 5 2
■ 40 100

VARIATION

■ 70 30 20 ■ 40 100
■ 70 80
■ 40 25 80
■ 15 15 20

■ 40 10
■ 50 10
■ 40 100

■ 70 30 25 ■ 40 100
■ 30 70 35
■ 10 40
 10

CAMAY

THE SOAP OF BEAUTIFUL WOMEN

CAMAY

PROCTER & GAMBLE · Made in U. S. A.

CAMAY WRAPPER, c. 1949 *I must admit to a love/hate relationship with this soap label. The colors are at once repellent and yet somehow attractive. There definitely is a feeling here of 1940s or 1950s bathroom tiles in the stark green, which was used to represent both water and sanitation. The female head emblem introduces an unexpected accent color and confers a classic pedigree upon this otherwise mundane brand of soap.*

57	WHITE	
55 45		
40 100		
8 35 30		

VARIATION

50 20		
40 30 100 15		
40 100		
5 3 10		

75 15	
50	
40 100	
WHITE	

100 70 10		
10 15 75		
35 30 60		
WHITE		

49

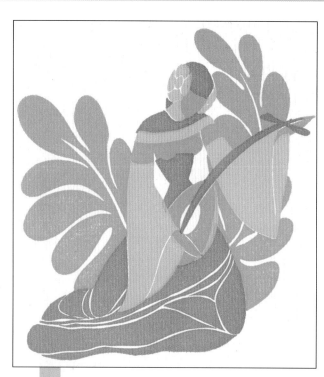

CHINESE FAIRY TALES, Sonia Roetter, 1946 *This charming and elegant children's book illustration is timeless in its style, and uses a limited palette of very unusual colors. Most likely the artist was influenced by a traditional Chinese color model. At the same time, the scheme is consistent with the color sensibility of the late 1940s, which had begun to anticipate that of the 1950s.*

- 40 10 40
- 9 50 40
- 75 10 40 10
- 2 6

VARIATION

- 50 5 15 WHITE
- 60 70
- 35 40 5
- 40 100

- 85 50 10 35 30 60
- 20 10 3 WHITE
- 50 15 15
- 60 30 100 55

- 65 100 WHITE
- 40
- 15 100 20
- 40 100

HOROSCOPE SCARF, c. 1956 *The colors of this scarf might have come from any time period but the drawing style betrays its 1950s origin. Cold-war-era colors are not usually this warm, although no single period in history (as we conveniently separate them by chunks) remained entirely consistent in the art that emerged from it. Yet for me, this scarf conjures up a 1950s feeling of knotty pine paneling and a pipe-smoking dad dressed in a suit.*

75 100 WHITE
22 30 55 5
15 70 75 20
40 100

VARIATION

50 30 5 10 20 40
10 30 15
30 70 100 40
50 30 100 30

30 35 60 10 WHITE
80 5 5
40 100
100 40

40 5 12 5
60 5 15
25 30 20
40 100

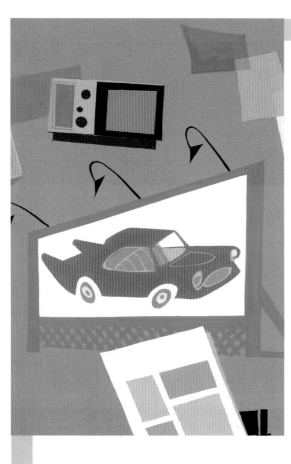

CARTOON BACKGROUND, c. 1959 *This gorgeous gouache painting from an unknown animated cartoon has come back full circle into high style. "Cool" is the only way to describe it. And that goes double for the color scheme, which may have been accompanied by a blues- or jazz-inspired score. We can only surmise about the characters who cavorted in the setting, but one thing's for sure: Someone ought to bring back those tail fins.*

45 55	40 100
15 70 25 3	30 40 7 3
85 50 7 6	WHITE
40 75 15 15	

VARIATION

10 15 35 20	10 20 100 10
60 5 5 18	40 100
85 35 35	WHITE
80 75 35	

30 10	40 100
60 80 100 15	WHITE
10 40 85 25	
15 60	

10 75 75
10 15 85 10
20 20 25 5
40 100

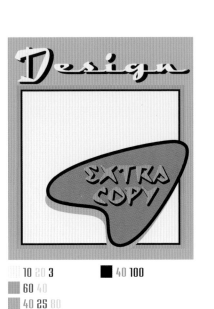

FABRIC DESIGN, c. 1959 *I regret that you cannot view, as I regret I did, the original fabric from which the art at left was scanned. In its sheer hideousness can be found a perverse beauty which, once again, is back in step with present fashion. One can only marvel at the mind behind such a design. Was the artist an abductee trying to describe the interior of a spacecraft? As for me, I'm still haunted by those bands of gold thread.*

25 5 ■ 40 100

30 20 85 15

3 4

■ 25 80 90 25

VARIATION

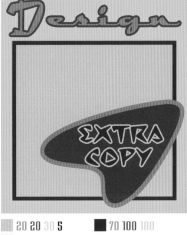

10 20 3 ■ 40 100

60 40

40 25 80

■ 60

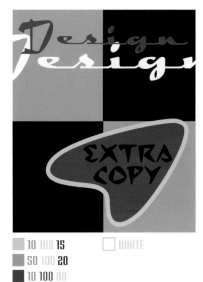

20 20 30 5 ■ 70 100 100

10 70 100

■ 10 100 80 15

30 100

10 100 15 □ WHITE

50 100 20

■ 10 100 80

■ 40 100

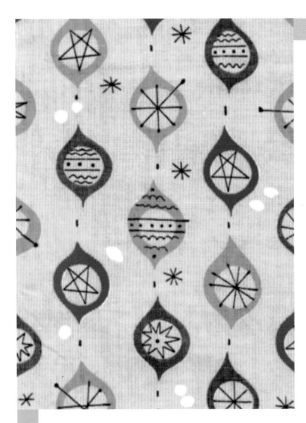

WRAPPING PAPER, c. 1956 *Here's a spin on the traditional Christmas colors of red and green. The linework on the tree ornaments seems atomic-inspired. This wrapping paper design reminds us of the interesting effects that can be achieved when expected color schemes undergo a courageous tweaking. What would happen if, next time, we decide not to color our sky blue and our grass green?*

25 15 10	☐ WHITE
95 6 35 **4**	
100 100	
65 55 50 **30**	

VARIATION

35 30		10 50 5	
50 20 17		■ 40 100	
15 100 20		☐ WHITE	
17 65			

15 75		5 25	
20 100 100 30		10 25 25	
30 15 20 10			
70 60 10			

80 100 100 15		■ 40 100	
60 80 10			
35 100			
15 35 25			

54

SOME OF THESE DAYS, Stein, 1957 *This book cover is designed in "retro" style. But not 1950s retro. The artist has attempted to portray a 1920s theme with "a lot of sass, no class," as Sophie herself once warbled. There is the suggestion here—mainly in the color scheme—of the old-time carny poster or the stage-side placards that would have announced performers such as Tucker back when she was the toast of vaudeville.*

■ 100 100	
■ 20 100	
■ 40 100	
□ WHITE	

VARIATION

■ 35 50 15		■ 50 85 20	
■ 30 75 75 30		■ 40 100	
■ 75 80		□ WHITE	
■ 15 75 10			

■ 100 100 50		□ WHITE	
■ 40			
■ 10 25 80			
■ 40 100			

■ 10 15 75 10		□ WHITE	
■ 20 100 80			
■ 30 20 35 15			
■ 40 100			

WRAPPING PAPER, c. 1954 *Gazing upon this baby-shower-themed wrapping paper takes a baby boomer back to his own infanthood. Sure, the pink, blue, and yellow have always been associated with the nursery, but the addition of a shade of gray roots the design firmly in the 1950s. More than a decade later, these same colors, turned up to full intensity in psychedelic posters and other 1960s graphics, would regale the eyes of these same now-grown babies.*

17		40 100	
70 5		WHITE	
45			
35 20 20			

VARIATION

15 100		3 15	
20 100 100			
20 50 15			
50 80			

20 100 100	40 40 50
5 25 3	70 45 70
15 100	20 50 100 30
15 75 20	

80 70 20	3 15
100 10 20	
60 100 20	
5 100	

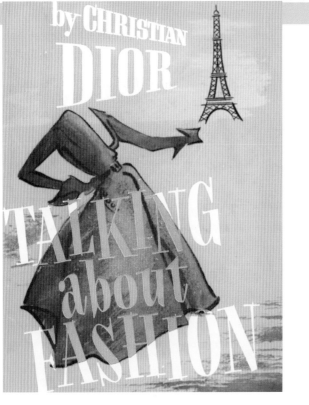

TALKING ABOUT FASHION, 1954 *The Eiffel tower, a Dior gown, plus pink, navy blue and khaki. How 1950s! As is still so often the case, the name of the cover artist was deemed too inconsequential to be identified. Note our variation layout, below right. It demonstrates how vastly different the same colors can look when their order and emphasis is reshuffled.*

VARIATION

25 15 35	100 80 20 30
4 10	
4 50	
60 25 20 4	

100	40 25
5 5 20	60 100 10
80 100 40	40 100 60 15
100 50 20	

10 25	15 90
10 20 73 15	40 100
100 90 40	
10 50 85 10	

10 40	70 35 20
50 40 100 15	40 100
10 20 100	WHITE
40 100 60 30	

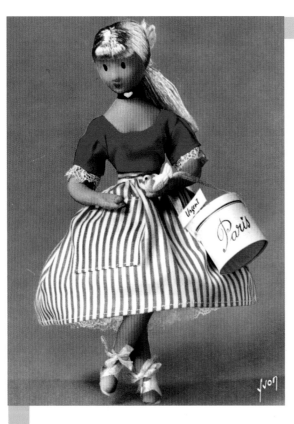

FRENCH POSTCARD, Yvon, 1956 *Despite the fact that the subject of the photograph is a doll, the design of this postcard evokes all the glamour and romance of Paris. This nostalgic image, with its 1950s blue-green background, reminds me of a drizzly day spent under a café awning in the Latin Quarter. Or maybe I'm just having an acid flashback. Anyway, this simple color scheme is simply magnifique!*

85 40 20 30	40 100
100 100	WHITE
50 55	
20 100	

VARIATION

37 20 5	40 100
60 40 30	
7 25	
90 80	

45 75	10
10 50 15 10	
90 20 60 15	
40 100	

10 65 70	14 9
7 20 100	
60 80 100 15	
10 15 5 20	

COVER, Tomde Heus, 1950 *This illustration from the cover of a Dutch paper industry journal was silkscreened in five opaque colors on a dark blue paper stock. Although this issue is the Christmas number, it seems more eerie than festive. Nonetheless, the art is attractive in that fine-artsy, quasi-abstract style that was the predominant direction illustration went in the 1950s. I like Heus's use of white to call attention to the central figure of the bird.*

30 10 17
75 40 35 17
25 47 70 3
20 100 90
40 100
WHITE

VARIATION

14 10 10
40 100 100 15
5 100 35
30 20 10
WHITE

30 90 90
20 100 100
5 20 20
15 20 10
15

10 15 35
10 20 100 10
10 50 100
40 100
WHITE

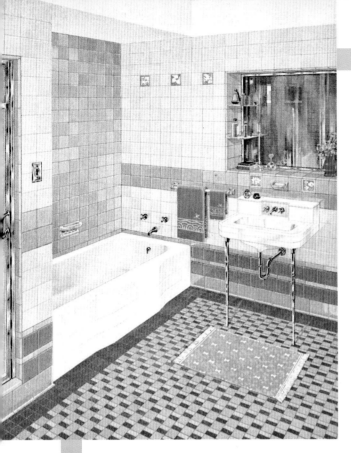

TILED BATHROOM, 1950 *With colors labeled dusky peach, buff, spicy nutmeg and pastel green, this bathroom tile design was hailed as "a happy solution to the dual demand for masculine vigor and feminine chic." The colors here are reflective of the "brown years" of the late 1940s, which followed the red, white and blue that was popular earlier in the decade. Rich yet subtle tile colors like these disappeared by the late 1950s and weren't commercially available again until the 1980s.*

25 70 85 10 3 4 5
50 20 45 7
5 20 30
75 30 20 20

VARIATION

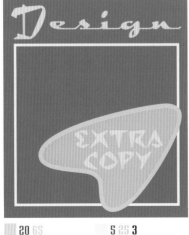

20 65 5 25 3
40 50
100 15 35
20 40 15

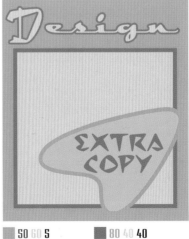

50 60 5 80 40 40
40 20 15
40 10 10
20 15 10

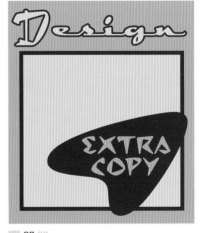

25 20
20 100 70 40
40 25 70

TILED BATHROOM, 1950 *I never would have guessed that this tile design represented the "Neo-Classic Trend" if it hadn't been labeled as such in the catalog advertisement from which this image came. Here we have walls of peach and a band of forest green. The floor colors include honeysuckle and lobelia. Anyone, in my opinion, would be lucky to have such a boldly hued environment cemented into her home.*

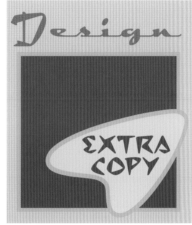

■ 5 30 40	■ 27 5 30
■ 100 70 15 5	
■ 55 10 45	
■ 85 30 35 25	

VARIATION

■ 50 20 5	□ WHITE
■ 50 10 5	
■ 40 30 100	
■ 40 100	

■ 70 40	■ 40 100
■ 40 5 20 5	□ WHITE
■ 60	
■ 10 5 20	

■ 30 70 10
■ 100 60
■ 55 55
■ 10 3 20

When we speak of design from the 1960s, *we are really speaking of two distinctly individual trends. The first trend, from 1960 to 1965, was comprised of the unwinding inertia of the 1950s aesthetic (itself an atomic revamp of the 1930s). Actually, early 1960s color contained the morbid dregs of a cold-war, crew-cut sensibility that considered any color stronger than pink, tan, baby blue or gray as likely to be part of a communist plot.* ◆ *By 1964, a new energy, instilled by musical groups like The Beatles, began to inspire a liveliness in type and color that foreshadowed things to come. The first half of the 1960s was, nonetheless, a pale and dismal period for color. The second half of the 1960s was influenced by the fine-arts genres of Pop and Op Art, along with the rock concert posters of the psychedelic movement. The use of formerly taboo color combinations of full-strength complements like red and blue or the eerie and nauseating orange and pink came as close to an LSD trip as one might imagine without the use of drugs.* ◆ *At the same time, the "Swiss" school of clean, grid-like design made an indelible mark. It emphasized heavy borders and a blacker "color" of sans serif types while placing white space upon a pedestal.* ◆ *Somehow, all of these influences, including major revivals of Aubrey Beardsley and other Art Nouveau designers, the trendsetting work of Push Pin Studios, the growth of interest in Eastern mysticism, and the vivid rainbows of Peter Max, came together in a tradition-shattering period from which the world has happily not yet recovered.* ◆ *As I like to say, Flower Power never died, it's just been repotted!*

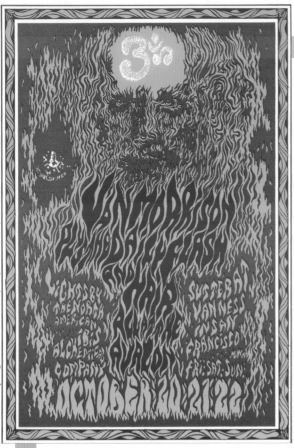

FAMILY DOG: VAN MORRISON, Wes Wilson, 1967 *The name Wes Wilson is to psychedelic rock posters what Campbell's is to soup. Wilson was the first to develop the classic wavy lettering style (as emulated in the word DESIGN below). The flame lettering in Van Morrison is another of his innovations. Wilson's vibrating psychedelic red and green type is intentionally eye-jarring. Some relief is offered by the stronger value contrast of the purple and green in the central type.*

70 S 100		
100 100		
53 100		
WHITE		

VARIATION

30 20	90 10 7	
70 100	40 100	
40 80 7		
100		

75 100	40 100
20 100	
35	
100	

25	
100 30	
100 70	
40 100	

THE CHAMBERS BROS, Victor Moscoso, 1967 *With a literally eye-popping color scheme typical of psychedelic posters, Moscoso's classy poster design for The Matrix is a clever blending of blown-up Pop Art halftone dots and trippy lettering grafted onto a conservative, symmetrical layout. All of this seems to prove that while the basic underlying qualities of good design remain the same, it is only stylistic details that change from decade to decade.*

100 40
47 100
10 95 5

VARIATION

100 25 ☐ WHITE
75 75 35
100
40 100

100
100
100
50 100

70 70

85 90
10 100 5
50 50
75 75 35

WRAPPING PAPER, c. 1965 *That tie you'll never wear may have come wrapped in paper like this. For all its gaudiness, the underlying drawing is smoothly confident and the color selection mature. And yet, like that tie, this paper served its ignominious purpose only to be cast aside. Yesterday's refuse, today's icons!*

▓ 3 60 ☐ WHITE **VARIATION**
▓ 30 100
▓ 53 70
▓ 30 60 40 **15**

▓ 60 50 ■ 40 **100**
▓ 10 20 20 **100**
▓ 90 15 5 **15**
▓ 25 15 **3**

▓ 45 25 100 ▓ 100 100 **40**
▓ 20 **100**
▓ 100 85 35
▓ 50 85

▓ 20 ▓ 100 75 15 **30**
▓ 20 100 10 ▓ 100 100 **40**
▓ 75 75 36
▓ 5 25

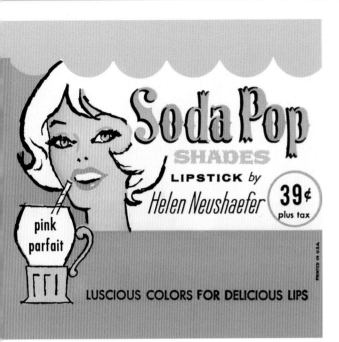

SODA POP SHADES, c. 1965 *A prime example of pre-psychedelic design. Aside from the woman's "Toni" haircut, the 1960s indicator here is the use of warm and cool reds together—in this case, hot pink and tangerine—which had long been an unspoken color taboo. Nowadays, add several dollars to that 39¢ price tag and you might be lucky enough to walk away with a lipstick as cool as "pink parfait."*

65 25	40 100
30 10	WHITE
65 10	
50 45	

VARIATION

80 100 40	70 75 15
80 100	50 85 10
20 100	60
70 80 35	60 80 100 20

30 40 80 30	WHITE
80 100 20	
10 50 70	
10 50 30 10	

40 100	40 100
100 100 10	WHITE
100 75 15 15	
100 40 10	

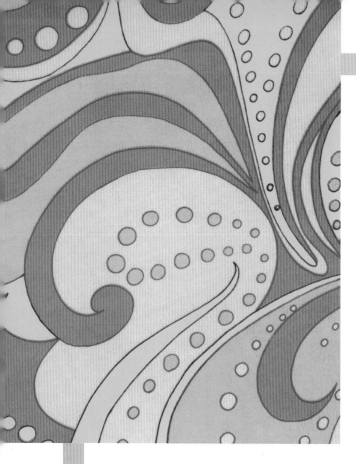

FABRIC DESIGN, c. 1969 *Fashion, here influenced by Indian batik prints and psychedelic light shows, seems to have captured the essence of the 1960s more boldly than the advertising, which remained practically conservative. Traditionally, there'd been a lag in time before advertisers would catch up to current trends, by which time the trend had become passé. Today, the situation is almost reversed, with advertisers, frighteningly, leading the way.*

23 20 25
53
35 85
50 90

60 100 10

VARIATION

25 100 8
100 100 20
85 20 20
100

40 100

100
100
100
60 100

100
100
30 100 13
100 100

WRAPPING PAPER, c. 1967 *The geometric pattern on this gift wrap draws inspiration from Op Art and suggests a futuristic influence (in that same funky way future technology is always hilariously portrayed in old movies). Although the shapes in the design might seem reminiscent of Art Deco, the very 1960s color scheme quashes the notion.*

VARIATION

75 13	15 85
90 90	75 80
3 40 50	
4 10 20	

25 35 5	
35 5	
40 100	
WHITE	

20 100	40 100
80 20 8	WHITE
10 15 35 20	
60 70 20	

6 75 80	40 100
35 5	WHITE
100 40 10	
100 60 10	

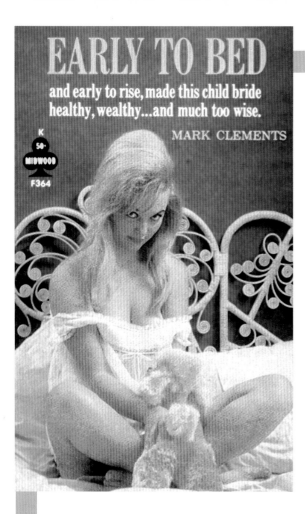

EARLY TO BED

and early to rise, made this child bride healthy, wealthy...and much too wise.

MARK CLEMENTS

K
50¢
MIDWOOD
F364

EARLY TO BED, 1964 *Pushed to the brink of nymphomania in reaction to society's utter denial of a woman's normal sexuality, this "child bride" chose to step out on Howard, her snoring fifty-year-old husband. Personally, I find such pandering to prurient attitudes and the exploitation of women reprehensible, although the colors are nice. The baby blue sheets and pink poodle contrast well against the cocoa brown seamless.*

60	30 50	
25 70 70 10	40 100	
17 70	WHITE	
40 15		

VARIATION

100 100	
80 100 10	
50 100 100	
WHITE	

10 20 20 100	40 100
50 60	50 85
50 60 15	
100	

35 85 10
20 70 70 30
5 5 15
40 100

FABRIC DESIGN, c. 1969 *The design reveals all the usual influences, from Peter Max to Yellow Submarine, but the colors are more laid-back than usual. There is something here that is reminiscent of the schlocky polyester housedress worn by somebody's Aunt Matilda. It is a quality that is both inexplicably attractive and simultaneously repellent.*

6 17 60
5 13 25
45 50
15 10 20

25 65 70 30

VARIATION

45 90 100 25
50 90 10
50 4 30

10 70
100 100
60 85
40 100

☐ WHITE

75 15
5 40 100
7 70 100
40 100

☐ WHITE

FABRIC DESIGN, c. 1967 *A design that really shouts 1960s, from its Op-Art-inspired trick perspective to its garish color scheme. Such colors, though seeming to break traditional rules, nonetheless have a quality that seems to communicate on some deep emotional level. And that may have been the designer's purpose, after all, in an epoch where radical new concepts were the rule, rather than the exception.*

VARIATION

■ 65 13 ■ 70 35 2 3
■ 55 6
■ 80 4 55
■ 90 100

■ 50 100
■ 70 80 10
■ 50 70
□ WHITE

■ 70 60 20
■ 100 70 10
■ 40 100
□ WHITE

■ 64 38 10 5
■ 35 40 5
■ 100 90
□ WHITE

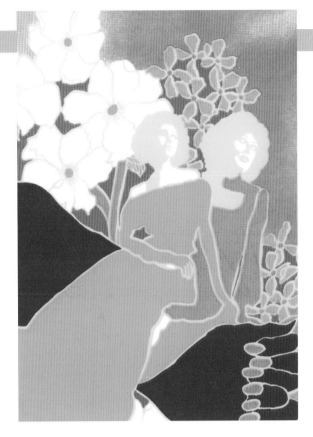

FABRIC DESIGN, c. 1969 *A masterpiece in polyester. This design brings together many fundamentals of 1960s color and style. Notice the contrasting of warm and cool reds, as well as warm and cool blues. The high-contrast treatment of the faces was handed down from turn-of-the-century poster artists like the Beggarstaffs via Warhol to such ready-to-wear clothing for the masses as this.*

4 65 100	20 40 85 5
80 10 40	45
90 50	
30 100 80 20	

VARIATION

18 50 5	40 100 20	100 20
100 60	100 30 10	100 40 40
40 100	40 100	50 5 5
WHITE	WHITE	30 15

40 100

MATCHBOX COVER, 1966 *From Russia with love comes this matchbox cover art. For all its blocky stylization, the design could be from the 1930s, but the color choices reveal its more recent vintage. The letterpress printing is slightly off-register, which on the yellow dress produces a darker red line as it overlaps the magenta. Elsewhere, as on the fruit, this overprinting effect is used on purpose to make a rich red.*

85 10		40 100
10 15 75		WHITE
50 20 80 7		
90 100		

VARIATION

10 100	40 100
100 100 10	
70 70 7	
7 70	

10 50 15 25	40 100 60 30
35 15	
60 35	
35 30	

100 10 10	100 75 15 15
20 65	
36 65 10	
30 100 100 30	

ROCK AND ROLL WILL STAND, Gisella Heau, 1969 *This cover struck a chord for its unusual, though highly effective, use of color. The designer made excellent use of two ink colors by combining red and blue as a bleed background and by allowing the solid red to appear by itself only on the author's by line. Heau selected a warm red instead of process red, so with process blue, the background became maroon instead of purple, creating a nice interplay of warm and cool.*

VARIATION

33 7 10
3 100 70
30 100 50 13
30 50 15 10

80 20
30 7 5
40 10
7 50

100 90
40 100
WHITE

80 5 20 30 40 100
75 10
70 70 15
70 15

What can be said about color at the edge of the millennium *except that it continues to follow a trend of trendlessness that began in the rule-breaking period of the late 1960s. Of course, there are still periodic color fads now as there always have been. Often it's the retailers who create them and pray that their predicted color schemes prove popular for the coming season.* ◆ *The recent tendency toward richly saturated, slightly muddied colors might be considered our current (1999) trend in color. At the same time, however, pure primary comic book colors, various retro color schemes, and fluorescent and metallic colors are equally popular.* ◆ *In this great age, the arts are beginning to be seen not merely as a sideline to work and family but as an*

essential ingredient in personal happiness. There is a tendency to place greater importance upon individual creativity, and the computer has provided easy access for many would-be artists. As more artists and designers create, experiment and trash old precepts, the result is a constant evolution of new visual ideas. It's not just microbes that are evolving too fast for science to keep up. ◆ *Current styles of design also borrow from past decades, especially from the 1930s, as seen in many of the following examples. Likewise, the new color schemes we see all around us on billboards, magazines and television are not really new at all. What is new is our ability to tweak colors to perfection and inexpensively proof our work until we are satisfied. Years ago, even the top designers had to place a lot of faith in a photoengraver or negative stripper (who was not an artist) and accept the result after one or two proofs.* ◆ *Fortunately, these times allow tremendous freedom to experiment with all makes and models of color. The rule for current color is, to borrow a 1960s saying, if it feels good, do it.*

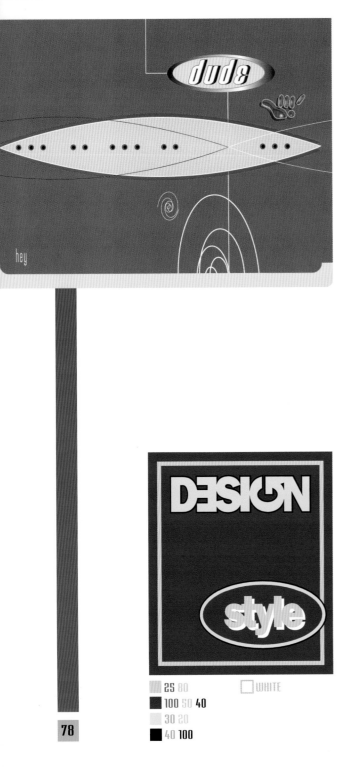

HEY DUDE, Irina Hogan/designer, Lorna Stovall/creative director, 1997
Expect the unexpected from Backyard, a design studio that doesn't compromise its avant-garde approach when working for a roster of "frontyard" clients. In this self-promotional postcard, the sensual brown background and golden yellow elements contrast with a surprising pink. The color combination does not sacrifice its cool by remaining warm and friendly.

VARIATION

▧ 18 10 10		■ 40 100
■ 100 100		☐ WHITE
■ 55 60 45		
▧ 15 75		

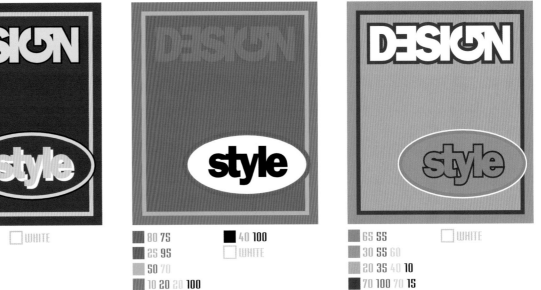

▧ 25 80	☐ WHITE
■ 100 50 40	
▧ 30 20	
■ 40 100	

■ 80 75	■ 40 100
■ 25 95	☐ WHITE
▧ 50 70	
▧ 10 20 20 100	

▧ 65 55	☐ WHITE
▧ 30 55 60	
▧ 20 35 40 10	
■ 70 100 70 15	

BUS SHELTER POSTER, Lorna Stovall, 1997 *To a Western designer's eye, Japanese brush script looks like nothing so much as fun design elements to play with (even more so when compared with our Roman characters). In this cola ad, Stovall has created a dynamite composition with an intriguing color scheme owing a small tip of the hat to the Eastern color sense. The clever addition of the English exclamation point reintroduces the product trademark.*

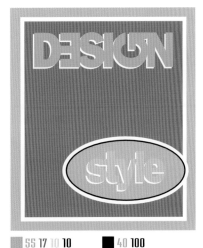

■ 55 17 10 **10**	■ 40 **100**
■ 30 10 52 **10**	□ WHITE
■ 20 80 90	
■ 5 18 50 **10**	

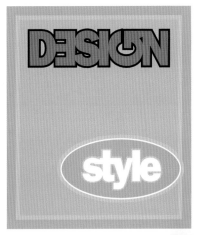

VARIATION

■ 25 60	■ 40 **100**
■ **100** 80 40	
■ 65 70 **35**	
■ 55 50 **5**	

■ 85 70	■ 25 10 **10**
■ 3 30 3	■ 25 5 **20**
■ 25 90	
■ 90 65 **10**	

■ 80 60	■ 20 **100** 70 **15**
■ 60 80	
■ 10 25 60	
■ 5 25	

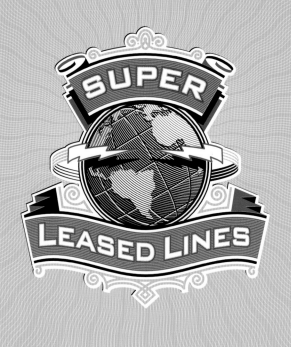

SUPER LEASED LINES, Daniel Pelavin, 1997 *Illustrator and type design-er Pelavin creates graphics on the Macintosh that would have been virtually impossible ten years ago when he (like the rest of us) was bound by pen and ink. With duplication, rotation of his strokes and shapes, and other simple tricks, Pelavin creates intricate designs that can be likened to the decorative steel engravings of one hundred years ago. He is also, obviously, an astute colorist.*

VARIATION

25 100 100 ☐ WHITE
26 26 67
16 16 40
40 100

10 100 ☐ WHITE
15 25 25 10
30 35 35 35
40 100

4 7 50 ☐ WHITE
25 60 100
30 70 100 40
100 40 40

55 40
75 37 100
20 5 65
80 47 100 40

HOOVER'S GUIDE, Daniel Pelavin, 1996 *It would not be impossible, by hand, to do what this designer does with a computer, but it sure is a lot easier now! Pelavin's created a dimensional highlight effect by simply sliding a copy of the drawing upwards a tad and painting it light yellow. He enjoys capturing the retro look, especially Art Deco, and few do it better. He manages to recreate the color spirit of those times while boldly updating it.*

7 5 50	65 25 100	
15 16 82	10 55 100	
30 33 82	3 3 65	
87 100 35		

VARIATION

25 85 100	20 17 70	100 55	40 100	100 30 50	65 10 50 15
7 40 20	90 30 25	60 100		10 100 70	
40 55 15		10 3 20		30	
80 85 25		100 60		100 10	

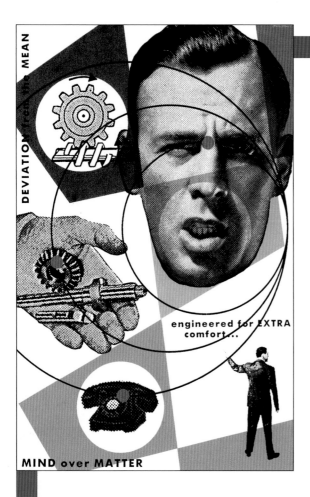

SCIENTIFIC NOTATIONS, Charles S. Anderson Design, 1993 *The design world has not yet recovered from Anderson's vision and has instead adopted it. His retro "found art" formula (which reportedly requires many grueling hours of detail work) has certainly found its way into mainstream design consciousness. Anderson's use of color has also been influential. His colors tend toward the industrial: grayed-down, muddy, humorless. Why this should turn out so brilliantly, I can't say.*

■ 40 35 85 10	■ 20 20 10 15
■ 75 35 45 50	■ 40 100
■ 23 85 50 10	□ WHITE
■ 12 45 75	

VARIATION

■ 30 60 25 5	□ WHITE
■ 60 25 5 25	
■ 25 50 15	
■ 30 100 50 30	

■ 10 50 85	□ WHITE
■ 100 75	
■ 10 5 15 5	
■ 100 35 35 15	

■ 50 70 10	■ 40 100
■ 15 25 55 15	
■ 77 45 15	
■ 45 10 5	

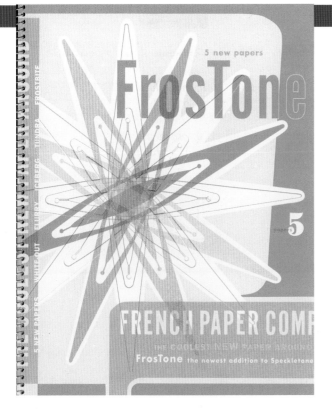

FROSTONE, Charles S. Anderson Design, 1998 *Anderson and designers Jason Schulte and Todd Piper-Hauswirth drew inspiration for this French Paper Company brochure from letterpress technical and ordering forms of the 1940s and 1950s, and the makeready waste sheets that printers use several times over while checking ink levels and registration. This accounts for the purposely overprinted colors and the ordered/disordered look that has become the Anderson trademark.*

VARIATION

15 53 75
30 10 15
47 15 40 5
15 2 25
25 15 60

50 60
100 20 20
15 50 55
WHITE

10 40
20 40 70
100 70 20
100 50 70

50 50 50
40 100

30 80 70
100 100
40
50 40

WHITE

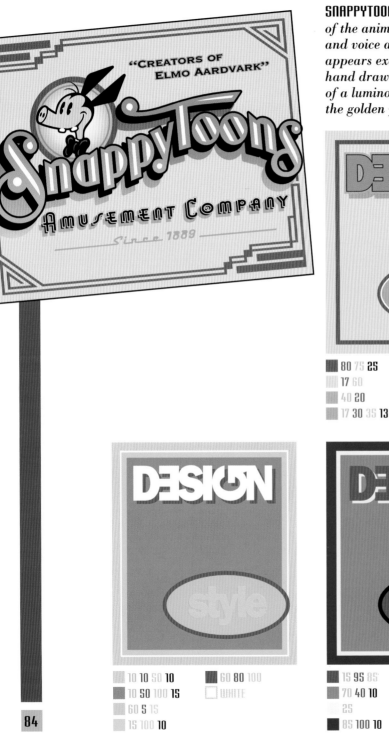

SNAPPYTOONS, Leslie Cabarga, 1997 *Elmo Aardvark, the classic star of the animated screen, is the modern creation of writer, composer and voice artist Will Ryan. In this logo design by the author, Elmo appears exactly as he might have in 1935. All display lettering is hand drawn in a period manner. An interesting color note is the use of a luminous amethyst-like lavender as a type drop shadow against the golden yellow background.*

80 75 25		80 70 17	
17 60		15 100 20	
40 20		40 100	
17 30 35 13		WHITE	

VARIATION

10 10 50 10	60 80 100	
10 50 100 15	WHITE	
60 5 15		
15 100 10		

15 95 85	40 100
70 40 10	
25	
85 100 10	

20 5
40 40
15 75 45
40 100

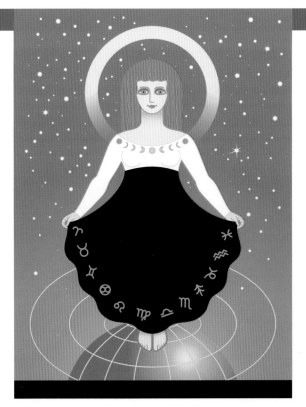

EARTH ANGEL, Leslie Cabarga, 1996 *The deep vermilion becomes the focal point of this holiday self-promo piece. Since this work is my own, I've decided to take a caption holiday.*

VARIATION

10 25 **3** 20 70
77 85 **7** 40 **100**
80 30 **20** WHITE
95 35 37 **17**

100 70 **10**
35 **7**
30
WHITE

20 30 20 30 70 100
60 35 40 100
80 35 20 **30**
35 15 **15**

20 30 20 30 70 100
60 35 40 100
80 35 20 **30**
35 15 **15**

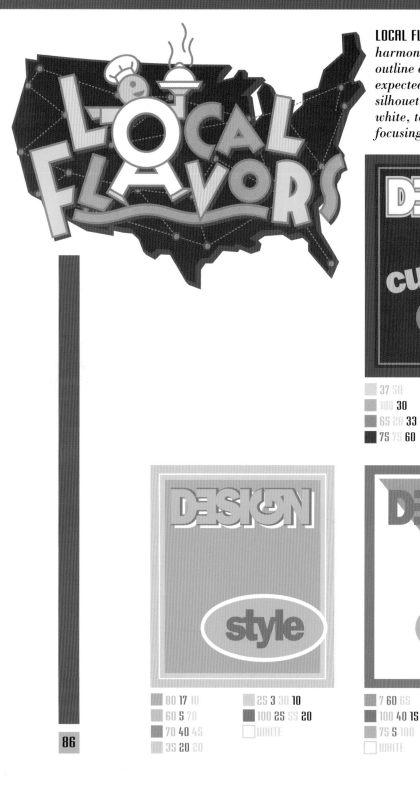

LOCAL FLAVORS, Michael Doret, 1998 *It takes a master colorist to harmonize so many sultry colors in one illustration. The same green outline applied to every letter helps unify the scheme. Instead of the expected black drop shadow on the lettering and the United States silhouette, Doret has "illuminated" it with a royal blue. The color white, too often considered a "noncolor," steps into a major role by focusing our attention upon the chef.*

37 50	100 85 10
100 30	40 45
65 20 33	25 75
75 75 60	55 87 WHITE

VARIATION

80 17 10	25 3 30 10
60 5 70	100 25 55 20
70 40 45	WHITE
35 20 20	

| 7 60 65 |
| 100 40 15 |
| 75 5 100 |
| WHITE |

5 10 10	40 100
30 65 40 10	
10 20 20 100	
65 70 20	

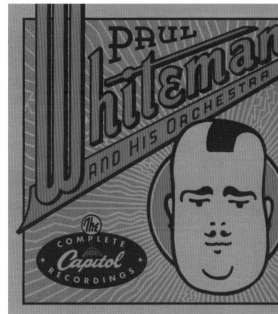

Illustration courtesy Tommy Steele, art direction, and EMI-Capitol Records.

PAUL WHITEMAN, Michael Doret, 1995 *In the 1920s and 1930s, "Pops" Whiteman was known as "The King of Jazz." Forget King Oliver or Louis Armstrong, and the fact that Whiteman was to actual jazz what white bread is to actual food. Music aside, Doret has captured the essence of period style, color and design in his loving homage to the band leader who, though ever portly, survived until 1967.*

30 38 85 13
3 90 100 2
100 100 10 30
100 5 33 35

VARIATION

35 5 25	50
67 10 50 30	40 100
25 25 65 10	
50 80 80	

90 50 10	50 80 50
50	
27 5 20	
10 5 5	

3 10 35	60 40 20
7 27 80	40 100
50 65 40	
10 20 20 100	

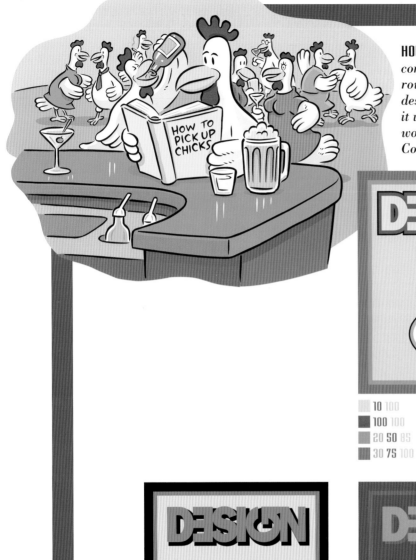

HOW TO PICK UP CHICKS, David Coulson, 1997 *Even from a complex illustration like this one, a color scheme may be borrowed. Coulson, who also specializes in lettering and logo design, begins with brush and ink. He scans his line art, cleans it up and begins coloring. This is how he gains the benefits of working with a computer while retaining a hand-drawn look. Coulson's bright colors are appropriate to his cartoon style.*

10 100		40 10	
100 100		80 70	
20 50 85		40 100	
30 75 100		WHITE	

VARIATION

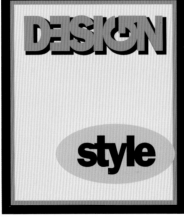

20 35
45 10 55
18 70 100
40 100

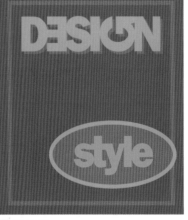

75 75 25
40 80 40 30
10 50 70 10
55 60 5

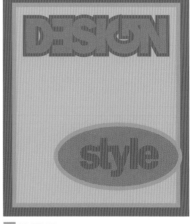

30 50 60
10 40 60
50 70 35
60 80 100

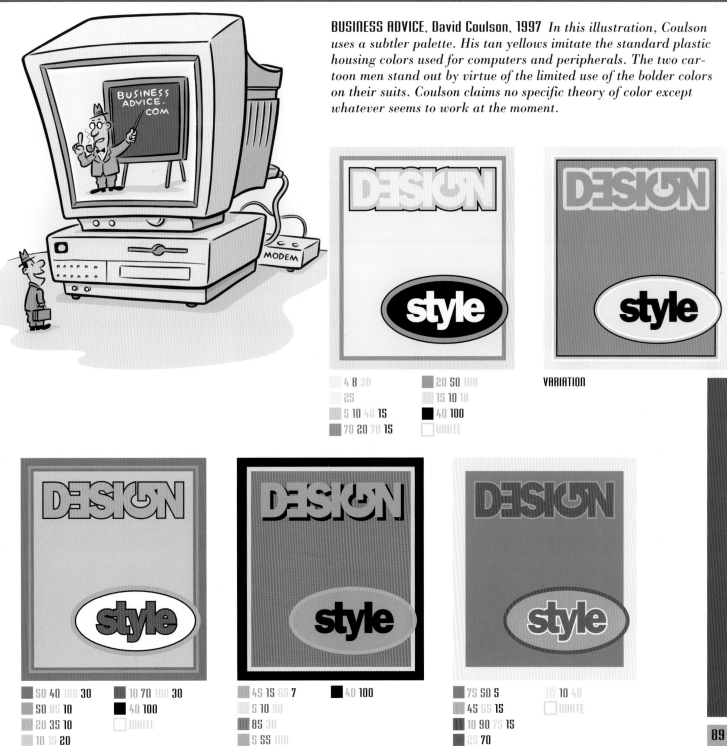

BUSINESS ADVICE, David Coulson, 1997 *In this illustration, Coulson uses a subtler palette. His tan yellows imitate the standard plastic housing colors used for computers and peripherals. The two cartoon men stand out by virtue of the limited use of the bolder colors on their suits. Coulson claims no specific theory of color except whatever seems to work at the moment.*

4 8 30
25
5 10 40 15
70 20 70 15

20 50 100
15 10 18
40 100
WHITE

VARIATION

50 40 100 30
50 85 10
20 35 10
10 15 20

10 70 100 30
40 100
WHITE

45 15 65 7
5 10 90
85 30
5 55 100

40 100

75 50 5
45 65 15
10 90 75 15
25 70

10 40
WHITE

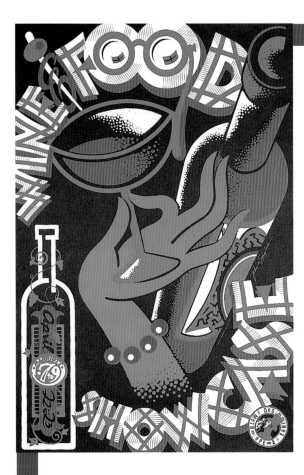

WINE & FOOD SHOWCASE, Sayles Graphic Design, 1996 *This poster reveals the designer's love of Art Deco motifs. The stippled shading effect was especially popular in old posters. Sayles's use of color might have seemed a bit unusual in the 1930s, but it works wonderfully in our time to create the desired mood of sophisticated elegance.*

35 80 30	80 70 40 **60**
60 30 100 **7**	WHITE
100 **40**	
20 100 40	

VARIATION

80 60 **20**	5 20
25 80	40 100
40 30 25	
20 20 20	

90 5 20	10 35 3
100 30 27	WHITE
100 60 40	
75 80	

40 30 60 **10**	10 15 20
55 60 15	40 100
80 75 35	
3 15	

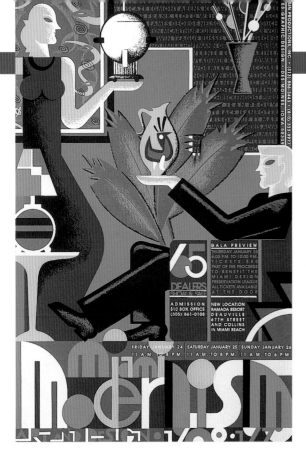

MODERNISM, Sayles Graphic Design, 1997 *A fine example of the use of Art Deco motifs in a current context. The arrangement of type is certainly contemporary, although the overall effect of the illustration is that of a carved relief panel one might find on the side of a 1930s office building. Again, Sayles's color is stronger and more deeply saturated than was typical in the 1930s. The picture may well represent the designer and his wife in their authentically decorated Art Deco home.*

VARIATION

30 85	90 50 67 15
95 40 10	40 100
67 90 90 15	WHITE
65 30 80	

25 60 5	35 20 5
35 50 30	
20 10 5 5	
35 75	

20 40 5	20 70
50 60 5	10 40 60 10
60 5 20 30	
10 50 30	

30 50 35 10	20 35 70 35
25 95	
40 70 7	
60 80 10	

POSTCARD, The Dyer Mutchnick Group, Rod Dyer, Steve Twigger, 1997

Well-known for hundreds of record and CD covers, movie posters, corporate logos and other design work, Rod Dyer and company continue to cut the edge of current color. In this self-promotional piece, one of a series of anima-centric postcards, the designers let loose an offbeat, sophisticated and sensual color sense, something that is not always possible in their work for clients.

VARIATION

23 18 40 **3**	50 30 17 **20**
35 17 50 **3**	50 20 60 **50**
20 75 75 **20**	
17 45 85 **10**	

70 100 100	40 **100**
60 80	WHITE
3 30 **7**	
100 100 **40**	

80 40 10	WHITE
100 70 40	
50 85	
40 **100**	

80 60 10	3 15 20
15 75	40 70
70 80	
10 30 100 **10**	

92

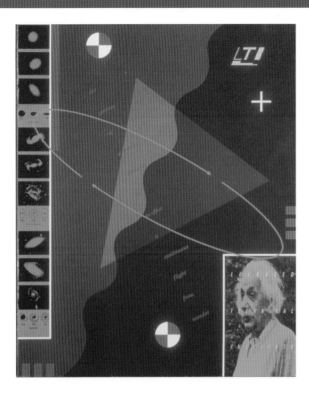

BROCHURE, The Dyer Mutchnick Group, Rod Dyer, Steve Twigger, 1996
A high-tech firm deserves a high-tech look. Visual motifs suggest astronomy, electricity and mathematics in a "post-modern" abstract geometric setting that might have pleased Albert Einstein himself. The designers have contrasted small areas of bright color accents, which appear to come forward in space, against a background of darkly muted tones to create a sense of dimensionality.

VARIATION

30 100 70	35 65 30 10
70 90	40 80 25 35
10 45	65 80 20 30
80 40 15	65 80 30 55

40 80	25 80
75 75 35	
70 80 35	
15 3 20	

50 5 20 10	55 60 5
65 10	40 35 70 10
65	40 100
5 25 20	

55 55	15 60
40 25	30 50 15
80 60	25 80
55	WHITE

93

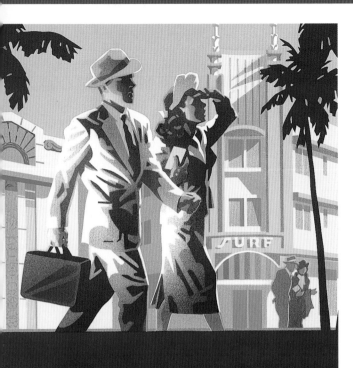

MIAMI STROLL, Laura Smith, 1997 *Smith is a perfectionist when it comes to color (and everything else about her work). She won't settle until she's mixed the opaque watercolors that she uses for the final airbrushing to her complete satisfaction. Smith's color combinations and design, as these samples reveal, are always exquisite. Her heroes are Otis Shepard (of Wrigley's Gum fame) and German poster master Ludwig Hohlwein.*

VARIATION

45 15 17 70 37 55
35 10 50 100 60 70 **30**
10 35 WHITE
25 45 80

20 10 35 **20** 30 60 100 30
85 35 10
40 80 10
7 10

35 20 25 40 100
50 25 10 10
35 20 3
20 65 30

7 15 20 WHITE
15 80 35 10
20 40 10
30 60 45

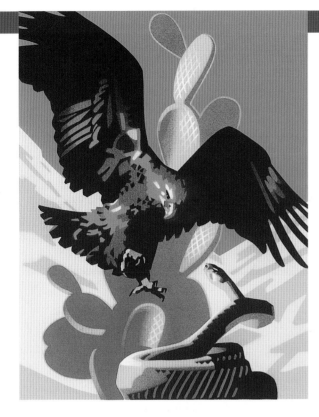

EAGLE, Laura Smith, 1997 *With an exclusively warm palette that includes an unexpected red-hot sky, the colors of this illustration place the viewer right in a scorching Mexican landscape. The toned-down values of the not-so-distant cactus suggest the heat rising from the desert floor. So often our color choices are arbitrary; in Smith's piece the color is used, as it should be, to support and enhance the meaning of the design.*

7 73 83
13 20 100
47 53 100 10
23 60 95

10 55
30 75
70 70 100 65

VARIATION

15 80
100 10 35
15 85 85
40 100 5

40 100
WHITE

65 75 45
27 67 7
7 5 30
55 50 3

100 60 30

50 73 100
100 7 40 20
80 40 100
35 25 100

40 100

A dozen instrumental jazz tributes
to *Frank Sinatra*
and his songwriters and arrangers,

including
- **"i've got you under my skin"**
- **"you make me feel so young"**
- **"i've got the world on a string"**

SINATRA LAND, Johnny Lee, art director; Andy Engel, designer; 1998
In this poster for a record release featuring a dozen jazz tributes to Frank Sinatra, Lee has captured the essence of that period in which the blue-eyed crooner reigned supreme. The musical instrument motif is given form by the three blocks of color behind it. These shapes are not arbitrarily placed. This example proves that there is a fine art to the design of seeming disarray.

8 13 50		WHITE
75 40 13 15		
6 87 85		
40 100		

VARIATION

45 25 100	40 100
5 60 15	WHITE
55 60 5	
15 50	

85 50 10	80 75 30
25 15 20	40 100
60	WHITE
20 30 70	

35 20 10	80 60 10
50 60 5	60 60 80 25
80 70	25 25
30 55 55 10	

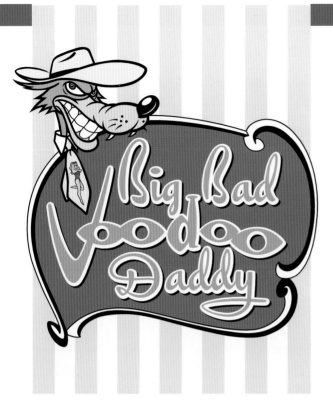

BIG BAD VOODOO DADDY, Andy Engel, Todd Schorr, designers, 1998

Schorr and Engel have injected bits of animator Tex Avery into a view from the atomic-age-interpretation of Victorian-era Bourbon Street. All of this fits in perfectly with musical group Big Bad Voodoo Daddy's "howlin' lounge" camp revamp musical aesthetic. That this funky mixture should come up current is no surprise. For years, the boys over at Capitol have capitalized on such timeless imagery as in this CD ad.

VARIATION

65 30 90	10 60	WHITE
45 90 75	25 35	
20 8 40	30 45 70	
20	40 100	

40	15 100 100
10 80 5	WHITE
70 100 80	
10 20 50	

90 30 80 40	5 50
65 60 20	
20 75 30 20	
65 65 5	

60 25 5
70 60
80 75
40 25 15

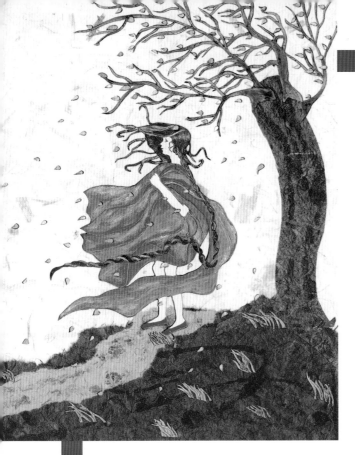

HOPE, Aga Kalinowska, 1998 *Combining exotic handmade papers and meticulous cut outs, Kalinowska's illustrations display rich textural and dimensional effects. Except for the flowing vermilion cape worn by the central figure, the colors in this piece are cold. How perfectly they suggest a blustery autumn day in which the hope of spring renewal is still many chilly months ahead.*

5 5 17
10 90 100
55 15 57
45 65 65 30

80 30 75 60
27 100 100

VARIATION

60 45 45
40 20
30
80 70 10

10 20 20 100
90 100 100 30

30 100 100 25
100 60 20
60 100
10 50 100 30

8 9
90 100 100 30

100 5 10 20
30 30
40 70
40 70 35

25
WHITE

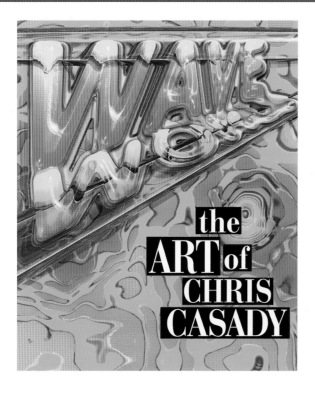

the
ART of
**CHRIS
CASADY**

WAVE WORLD, Chris Casady, 1998 *Casady, a special effects animator and 3-D illustrator, creates brave new worlds with a few strokes of the mouse plus dozens of hours of render time. In this retrospective brochure cover, the sizzling subtleties of the color palette are partially the rendering program's own creation as it "realizes" for Casady the wavy world of his fantastic imagination.*

15 100		25 45 100 15
3 50 100		40 100
80 100		WHITE
70 100		

VARIATION

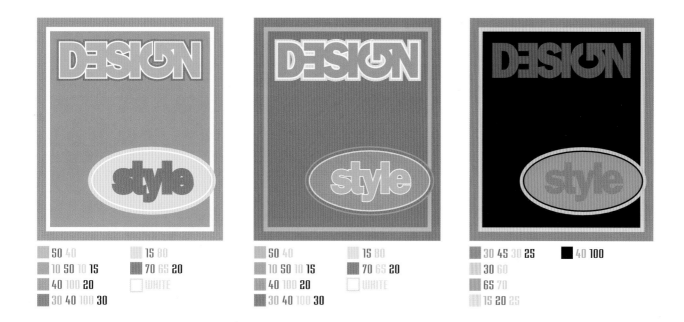

50 40	15 80
10 50 10 15	70 65 20
40 100 20	WHITE
30 40 100 30	

50 40	15 80
10 50 10 15	70 65 20
40 100 20	WHITE
30 40 100 30	

30 45 30 25	40 100
30 60	
65 70	
15 20 25	

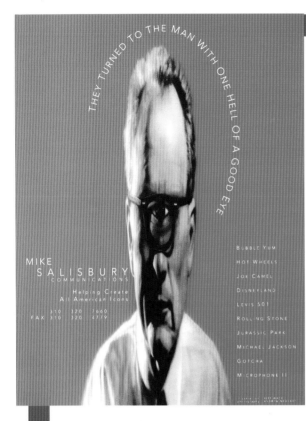

MIKE
SALISBURY
COMMUNICATIONS

Helping Create
All American Icons

310 320 7660
FAX 310 320 4779

BUBBLE YUM
HOT WHEELS
JOE CAMEL
DISNEYLAND
LEVIS 501
ROLLING STONE
JURASSIC PARK
MICHAEL JACKSON
GOTCHA
MICROPHONE II

SELF PROMOTION, Mike Salisbury Communications, 1998 *From Mike Salisbury, known for his high-concept campaigns for major national accounts, comes this "eye-concept" self-promotional advertisement. The Photoshop illustration is by Jeff Wack from a photograph by Andrew Neuhart. The colors here are strange—strange good! Since the late 1960s, Salisbury has been a trend-setting progenitor of the California hip style, helping to make it popular worldwide.*

5 90 75	60 30 50 30
10 40	55 10
50 20 45	40 100
43 3 10	WHITE

VARIATION

35 20	40 100
20 65	WHITE
60 80	
65 35 60 35	

90 50 30	100 90 90
70 25	
10 40	
100 40	

100 50 30 15	40 100
60	
90 75	
95 90 35	

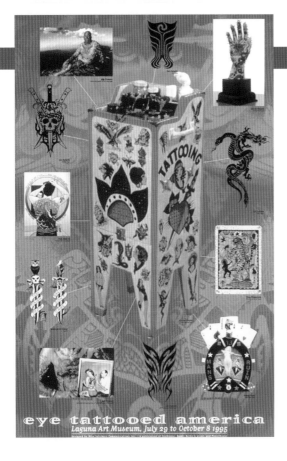

EYE TATTOOED AMERICA, Mike Salisbury Communications, 1995 *It's rare when the graphic elements supplied to a designer are as fun as these photographs and examples of tattoo "flash." The common white and/or gray-blue tones found in each of the small photos contrast well against the saturated brick red and green background. The unexpected all lowercase display type at bottom is punchy and eye-catching.*

� 70 20 75 5		▮ 25 80 80	
▮ 20 90 100		▮ 40 100	
▮ 5 40 65		☐ WHITE	
▮ 25 30 17			

VARIATION

▮ 30 80	▮ 30 65 65 30
▮ 70 60 30	☐ WHITE
▮ 10 30	
▮ 20 65 65 20	

▮ 30 80	▮ 30 65 65 30
▮ 70 60 30	☐ WHITE
▮ 10 30	
▮ 20 65 65 20	

▮ 20 20
▮ 20 60
▮ 45 10
▮ 85 50

color

Few designers choose to work with limited color. *Usually, it is a choice thrust upon us by a cost-conscious client who may, at times, be ourselves. But limited color—unlike, say, a limited diet—does not have to be a bad thing. The examples in this chapter prove that.* ◆ *Limited color can be challenging. It forces us to learn how to get the most bang for our limited buck. It can also yield results that are bolder and more dynamic than a busier, multicolored effort.* ◆ *The costs and limitations of printing technology in years past caused designers of periodicals, posters and packaging, among other items, to use only two or three colors in their printing. That's why modern designers who like to emulate the poster and graphic art styles of olden times often purposely choose a limited palette.* ◆ *Having to overprint tints of only two or three inks to create different colors may be used to one's advantage. It almost assures that all colors will be harmoniously integrated. Because solid coverage of an ink color looks stronger when printed, designers historically have tried to avoid the "compromise" of halftone dots. That may have been so when only coarser screens of 65, 85 or 100 line were available. But now, with 150 line and finer screens becoming standard, the dots of the halftone screen have become less perceptible to the naked eye. And, just as the painter may temper a tube color by adding some white pigment to it, the designer may also benefit by introducing some "light," a five or ten percent white dot, into an area of solid ink coverage.* ◆ *The examples in this chapter lend themselves to spot-color printing in addition to CMYK. The reader may find PMS equivalents to the colors shown here. In several of our sample layouts, one or more of the colors have been shown in other swatches reduced as halftones.* ◆ *In an ideal world, all our jobs would provide us the opportunity for twelve custom-color printing inks (plus spot varnish). And then, whenever we happened to feel like it, we could use only two.*

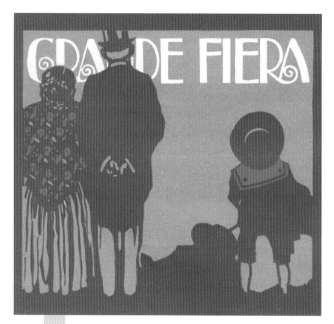

GRANDE FIERA, Aleardo Terzi, 1913 *What happens when you mix transparent red and purple inks? You get deep maroon and a three-color job for the price of a two-color job. The treatment is deceptive, however, since the red in its pure, unmixed state is used so sparingly. The lettering, as the only white element, becomes a strong, legible contrast against the highly saturated background. God, they did great work in the old days!*

- 25 50 15 10
- 25 90 70 15
- 90 75 3
- WHITE

VARIATION

- 60 20 5 10
- 75 80
- WHITE

- 80 75 10
- 35 85
- 15 35
- WHITE

- 85 85
- 35 35
- 45
- 40 100
- WHITE

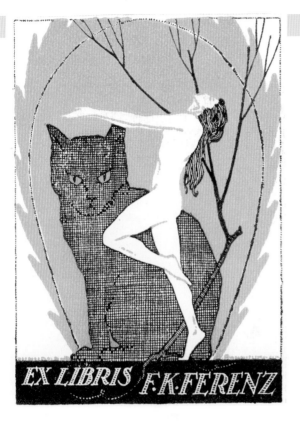

EX LIBRIS, 1928 *The bookplate sticker may be a dying artform, but this example comes from a time when the practice was still widely in vogue. This mystical design is printed in two colors. The yellow background color alone has been used to delineate the figure of the woman. What she has to do with book collecting is anybody's guess, unless, of course, Mr. Ferenz's library consisted of dirty books. We'll just never know.*

VARIATION

45 100
40 **100**
3 15

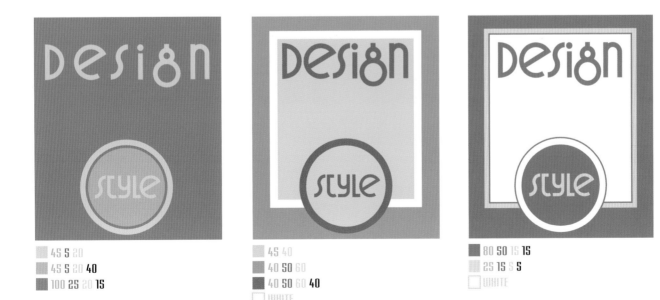

45 5 20
45 5 20 **40**
100 25 20 15

45 40
40 50 60
40 50 60 **40**
WHITE

80 50 15 **15**
25 15 5 5
WHITE

THE TEAPOT, Charles Buckles Falls, 1926 *This drawing in brush and ink by the famous poster and lettering artist C. B. Falls captures a scene in a then-popular Greenwich Village cafe. It's difficult now to imagine, but there was a time when smart couples like this pair actually considered it hip to smoke cigarettes! In his color scheme, Falls has created a subdued atmosphere against which the woman's vermilion getup strikes a powerful note.*

30 30 40
85 95
40 100
WHITE

VARIATION

30 15 35 20 7 5 10 4
60 80
35 45
15 10 20 10

55 60 15 WHITE
25 30 8
30 15 9
15 8 1

30 50 85
90 100 100
WHITE

TO GET SMART APPLICATIONS, YOU NEED MORE THAN MAGIC. YOU NEED THE REAL-WORLD POWER OF APPX. PLAIN-ENGLISH RULES-BASED RAD/CHANGE. READY-TO-GO INTEGRATED BUSINESS APPLICATIONS. THIN-CLIENT TECHNOLOGY. 110% PERFORMANCE. AND LONG-HAUL PERSONAL SUPPORT. YOU'LL WORK SMARTER. YOU'LL WORK FASTER. CALL 1-800-TRY-APPX OR WWW.APPX.COM.

Real. Smart. APPX.

APPX SMART

GET SMART, John Homs Design, 1997 *The bold typography playing over a field of green creates an interesting positive/negative interplay. In this advertisement the type itself becomes the illustration. Its arrangement seems influenced by the Art Deco or even the Dada style. In the Deco manner, Homs makes some letters, like the S in SMART, change color as they overlap the black T. Yet the choice of fonts and the shade of green leave no doubt as to the flyer's recent origin.*

VARIATION

65 100
40 100
WHITE

100 90 10
30 25 3
WHITE

25 30 10
35
40 100
WHITE

70 80 10 WHITE
50 30 5
40 45 5
20 15 3

TAREYTON CIGARETTES, 1929 *This sophisticated advertisement aimed at an upscale market just goes to show the power of design, which can sell the same poison to the rich man as to the poor man by simply changing the marketing approach. The colors here are very nice, however, and the scheme would work just as successfully today. The designer has made an effective contrast between two different shades of blue, one dark and the other lighter.*

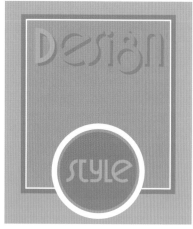

VARIATION

18 45 85 **10**
80 35 5 **13**
55 27 10
☐ WHITE

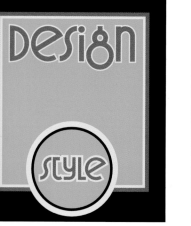

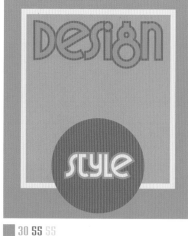

100 40 ☐ WHITE
50 20
20 100
10 50

80 60
30 20
65
40 100

30 55 55
10 55 55
30 85 85
10 15 15

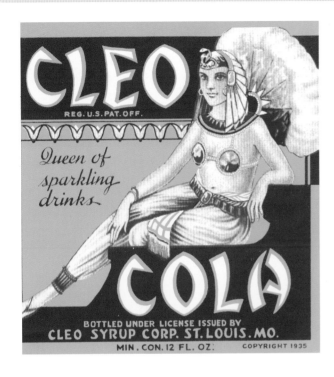

CLEO COLA, 1935 *At first glance, this wonderful design for Cleo Cola seems to be a four-color printing job. Closer inspection reveals a crafty two-color scheme in which transparent inks, printed full strength and in halftone, have been overprinted to create additional colors. Red and green seem to be especially versatile for this purpose, as a wide range of shades and colors can be achieved.*

45 30 ☐ WHITE **VARIATION**
35 100 75 40
30 100 100 7
65 80

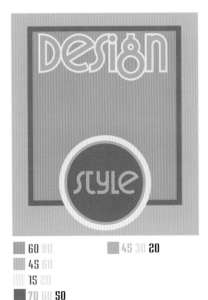

60 80 45 30 20
45 60
15 20
70 60 50

60 100 100 85 35 15
30 50 40 20 10 5
15 25
70 50 25 10

70 100
40 60
20 30

109

SERVICES, Leslie Cabarga, 1998 *This illustration appeared on the cover of a journal published by a financial services company. It was originally printed in two PMS colors, which have been replicated here. The orange-and-blue color scheme is appropriate to the retro style of the piece. Because it has been used more sparingly than the solid and halftoned shades of blue, the orange adds "punch" where it appears in the illustration.*

50 100
100 37 15
25 10 4
WHITE

VARIATION

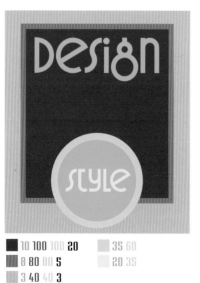

10 100 100 20 35 60
8 80 80 5 20 35
3 40 40 3
60 100

30 30 90 WHITE
20 20 75
10 10 40
5 5 20

100 50 40
35 50
WHITE

FOOD FAIR, c. 1959 *What could be simpler or more effective than this delightful matchbook cover design? The point to be learned here is that it's not how many colors you use, but which colors you choose! The bold placement of black and white also contributes to the success of this arrangement. Our variation layout again demonstrates how differently the same two-color job (plus white) can look when the color positions are changed.*

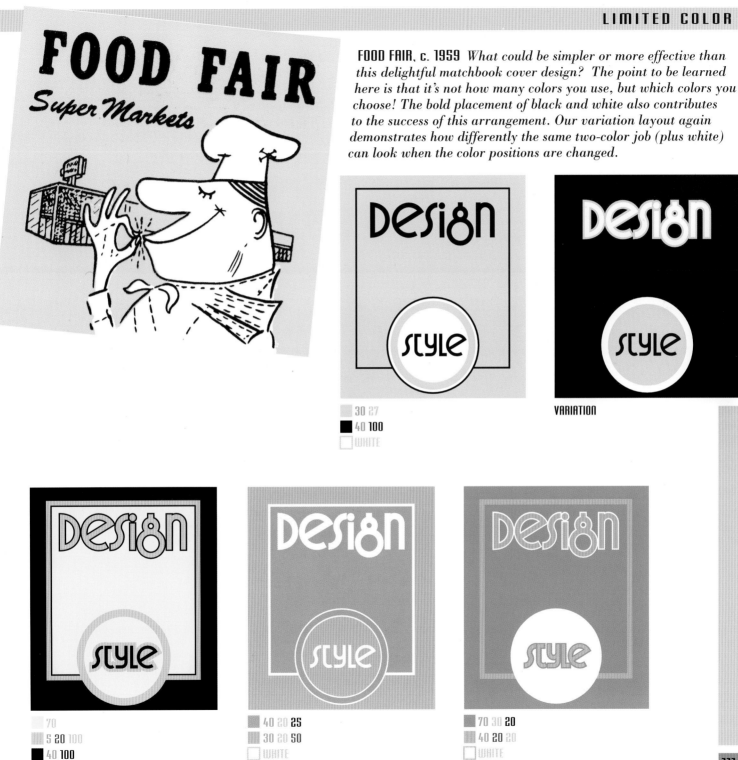

30 27
40 100
WHITE

VARIATION

70
5 20 100
40 100

40 20 25
30 20 50
WHITE

70 30 20
40 20 20
WHITE

L'ART DECORATIF FRANCAIS, 1928 *Generally, I prefer complexity, but this simple piece is one of my favorite images in this book. The design may be the work of one of those designers who, not actually knowing how to draw, proudly adopts the mantle of minimalism. The colors are strangely beautiful and very sophisticated. The gawky lettering, which I admire despite its being unevenly drawn, shows the earnest naïveté of a strictly T-square-and-compass guy.*

35 55 60 35
30 25 35 5
8 5 12

VARIATION

60 100 10
20 100
15 25 3

55 95 90 6
45 50 40
30 10 30

45 25 95
100 40 40
40 100

FRAMING THE DISCUSSION, Michael Doret, 1998 *Doret, once a T-square-and-compass guy himself before taking a bite out of the Macintosh, certainly knows how to draw. His letterforms are first-rate and his technical virtuosity gives form and credibility to his heartfelt revivals of classic lettering and design. Here, Doret chose to limit his palette in imitation of old two- and three-color packaging labels and show card designs. (The light blue is a reduction of the darker blue.)*

VARIATION

9 45 **5**
95 80 30 **15**
45 40 10 **5**
80 100

45 60
20 45
40 100

100 70 90
80 30 50
60 10 50

90 50
50 25
40 40 40

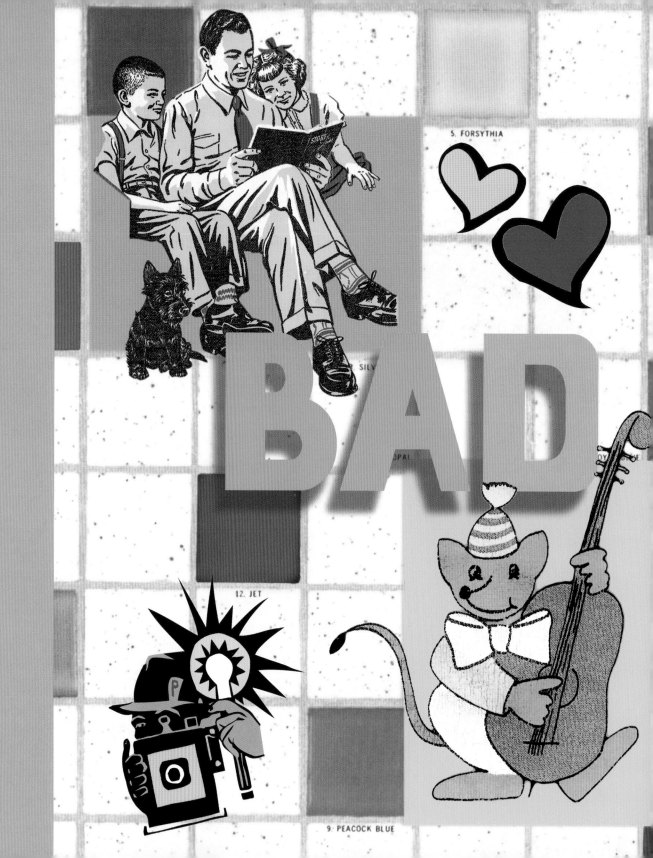

In a culture in which truth is anathema to power, *what was once considered good is now considered bad. Natural human urges for creativity, free spiritual exploration, unfettered sexual expression and true self-dominion have become suppressed by American society to such an extent that anyone exhibiting such tendencies becomes by definition perverse. It's as if to say, "If you deny me my inner truth and tell me I'm bad, I will be*

bad." This is also the reason that once-taboo color combinations have become perversely attractive. Now we find bad and ugly color being consciously applied to design precisely because it is bad…or simply very interesting. No longer is it just the color-ignorant who are responsible for bad color. Nor is it the fault of aging nine-to-five designers still employed in the dimly lit bull pens of Con-Tact paper and Formica companies. In light of this, I predict that this section may become the most popular in the book. Some examples in this chapter represent amateur attempts at color combining. Other examples are not produced in ignorance but in willful defiance of everything previously thought to be an inviolable standard of decency. Bad color, for our purposes, does not mean bad values or random arrangements. Despite the crummy colors in this chapter, I've attempted to maintain a decent, legible and viable distribution of color values. I admit that the "bad" color combinations seen here are according to my own prejudices. How could it be otherwise? But hopefully, you'll hate them too. Some cultures have vastly different tastes in color than our Western one. The Japanese, for example, seem to put colors together that defy our comprehension—and yet they work…in a weird way. Just look at Japanese packaging design. Shocking, awful and yet fascinating. For those seeking out odd or offbeat color schemes, check out the graphic design of other cultures. And remember, today's bad colors will become tomorrow's color forecasts.

STORY TIME, 1957 *Here we have what appears to be a typical 1950s nuclear family. . .in the middle of a nuclear explosion. Or is the fluorescent lighting just a wee bit strong? The color combination of green and magenta is frightfully close to being a complementary one, but there is no harmony here. While the family seems engrossed in some paternalistic, patriotic piffle, the Scottie dog appears to be thinking, "First chance I get, I'm hightailing it out of here!"*

30 3 75
25 90 30 5
3 20
40 100

VARIATION

15 75 40 45 85
50 15
35 85 10
75 30 75 50

3 5 65 10
15 13 45 15
20 50 67 30
7 7

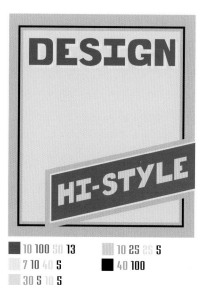

10 100 50 13 10 25 25 5
7 10 40 5 40 100
30 5 10 5
30 7 10 20

SUNBURST CREATES, 1935 *I'll be darned if any indication of a sunburst can be found in this paper sample brochure cover. But there is a strong suggestion here of a government housing project. The colors—one of which, tan, is the color of the paper itself—also seem to evoke the Great Depression, at its height in 1935, because these colors really are depressing!*

VARIATION

30 33 55 5
35 80 90 30
60 6 25 5

25 15 10 WHITE
40 20
50 27 60 25
20 35 20

30
65 15 15
20 7 15 7
55 15 30 20

25 20 65
30 5 40 13
55 30 25
5 6 10 3

MUSHROOM SUNFLOWER, c. 1970 *Perhaps at this very moment your own cupboard shelves are slathered in contact paper bearing this design. Recommendation: Give your landlord thirty days' notice! I really have nothing against the color brown, but I just hate this particular color scheme, and I hope you do too.*

75 100
7 25 90 3
25 80 100 25
3 4 4

VARIATION

3 20 40 45 85
20 10 20
10 30 15 20
75 30 75 50

50 50 30
5 20 70 7
40 30 30 30
50 85 20

100 10 100 20
10 85 15
67 35
2 7 7

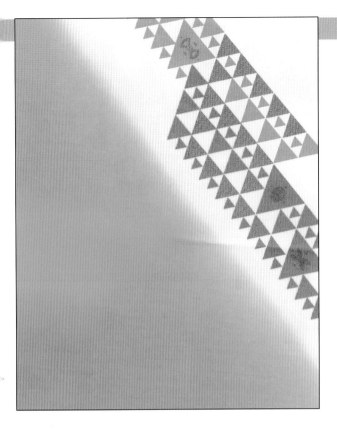

FUKUSA, c. 1962 *You might never think of using a silk napkin like this for your Earl Grey but it's an essential part of the traditional Japanese tea ceremony. The colors set my teeth on edge, though I secretly like them, as I do so many of the unusual Japanese color combinations that have luckily fallen beneath my gaze. Look to the Orient for truly startling and original concepts of color. Copy them just as they've co-opted funny American phrases. Call it free trade!*

VARIATION

60 25 7 7
70 7 70 **3**
40 65 5 **5**
30 40 95 **13**

55 10 **5**
30 20 **10**
3 3 10

75 40 **100**
100 7 10 ☐WHITE
80 **90** 10
100 80

5 60 20
20 25 35 **25**
25 100 25
10 15 **13**

FAME FORTUNE, Lorna Stovall, 1997 *The colors of this self-promotional postcard are so out they're in, so wrong they're right. And it is quite possibly just outlandish enough to achieve the very purpose for which it was designed: to attract attention. And that's no small feat in today's overly graphics-saturated world. This attempt to break through visual overkill may be the reason for the strange color schemes used by today's hottest designers. But army green and hot pink...now, really!*

6 100 7	100 20
100	40 100
60 40	WHITE
30 100	

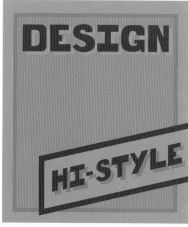

VARIATION

50 60 70
30 40 45
75 20
WHITE

15 75	WHITE
10 40 100 15	
40 30 30	
50 85 20	

120

50 50 15
60 80 45
80 30 80 6
100 40

BACKYARD PATTERN, Lorna Stovall, 1997 *This overall pattern used on a self-promotional piece by the studio Backyard would, in a kinder, gentler era, have made many designers cringe. But that was then, and this is now. Now such colors are "hi-style" in the same sense that orange juice is "fresh-squeezed" and little Johnny will sleep soundly tonight secure in the knowledge that here in America, if you don't like somebody's taste in color, you can log on to the Web and flame.*

10 5 □ WHITE

30 20 47

30 90 100

VARIATION

85 25 100 65 100 15

50 20

25 60 70 17

75 40

50 10

75 75 35

40 45 85

15 20 15 10

20 100 5 6 10 2

20 25 25 25

25 100 25

60 80 2

GUITAR MOUSE, c. 1964 *German clothing, such as the children's pajamas this illustration comes from, is made to last (unfortunately). It's got to be strong to withstand the typical three-hour cycle of German washing machines. What that has to do with color I can't say, but I can say that in America stricter import controls may be in order. I think it's the combination of green and gray against pink that worries me most.*

3 35 5		■ 40 100	
10 3 55		□ WHITE	
40 30 25			
60 5 55			

VARIATION

40 50 15
40 35
40 20
50 45 20

65
10 45 45
40 30 30
□ WHITE

40 20 100 25
60 100
100 50 50 5

THE BEATLE GUITAR BEAT, 1965 *This collection of sheet music was so good they named it twice (but changed the title colors the second time around to avoid confusion). The fab four are all here: red, yellow, blue and green, that is. But oh, the shades! This color combination demonstrates how a decent color like yellow may become entirely obnoxious, especially—since context in color is everything—when it keeps company with other bad colors.*

90 25
90 50
5 5 100
90 25 100 20
40 100
WHITE

VARIATION

70 10 60
75 30 30 20
15 75

20 100
100 100 50 10
100 25 25 15
45 45 60 5

40 65
45 25 100 15
35 50 67 10
50 17
60 75 100

color

Some of the most beautiful color combinations in use today *are those called earth colors. Traditionally, earth colors have come from the naturally occurring raw pigments found below the earth's surface and above it in nature. As our examples show, earth colors do not have to be somber and brown, the colors of dirt. Earth colors are also the colors of sunsets and, you know, rainbows and unicorns and stuff.* ◆ *Throughout history there have been periods in which earth colors have enjoyed popularity until some hot-headed designer realizes that glaringly bright, starkly pure colors are fresh looking, and then the color tide turns once again. In today's uniquely eclectic design climate, earth colors share the stage with colors of other palettes.* ◆ *Originally, all color was earth color. Metal oxides, cadmium, alizarin, cobalt, lead and other wonderfully poisonous natural earth substances formed the basis (and still do to a great extent) of painters' pigments, fabric makers' dyes and ceramicists' glazes. And then the scientists took over, introducing chemically produced colors which have given us inks and colorants in shades never before possible—and equally as toxic as their natural counterparts. Safe alternatives to poisonous dyes and colorants so far are few. That's why organic clothing and fabrics tend to run the color gamut from beige to…um, beige.* ◆ *But we must turn around our notions of color and just say no to any hues that cannot be safely produced. White is not right if bleach and its evil stepchild dioxin are required to make paper and fabric. As long as we keep our colors in our monitors and never print out anything, eye strain and EMF radiation are the only downsides to wonderful colors.* ◆ *Until environmentally friendly inks and dyes become more widely available, I say let it all be beige.*

HOBBY HORSE, 1929 *In colors of sandstone and terra-cotta, this illustration with its Egyptian or Arabian motif looks as if it had been carved on a temple wall. The green rounds out the color scheme, preventing it from being too earthy. The black adds a striking accent without which this design by an unknown illustrator might have appeared too cheesy.*

15 75 85 20	40 100
8 30 65	
60 3 70 10	
15	

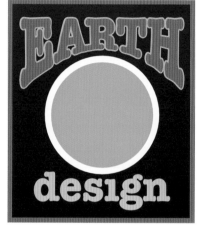

VARIATION

35 50 25 25
35 35 3
30 35 25
80 30 5 15

100 40 20 10	10 30 40
47 17 60 25	60 10 100 7
50 75 75 10	27 7 100 3
35 27 57 3	

17 15 10	10 30 100
30 65 75	
60 35 15	
35 17 80 5	

LANDSCAPE, 1930 *A wonderful composition and coolly appealing colors distinguish this calendar illustration from the Deco period. It is printed in five colors, but some overprinting results in a sixth, darker color that the artist has designated for use in shadows. Of note is the artist's lack of outlining. Instead, the ink selections cover an ample range of color values, enabling the colors themselves to suggest form.*

55 35 25 10	50 35 40 15
60 40 30 70	WHITE
20 30 40	
20 70 75	

VARIATION

40 80 35
7 40 100
30 70 50 15
40 30 25

45 50 5
25 75 100
15 50 5
30 70 50 15

60 80 100	10 3
30 30 60 10	
20 40 5	
65 20 30	

SZABADSÁG HOTEL, c. 1925 *As a hotel advertisement, something like this would never "play" nowadays. But back in the 1920s, this small souvenir from an overseas trip would evoke images of hearty meals of crusty homemade bread and goulash, and gypsy violinists in a quaint dining room; a hand-painted folk art headboard and curlicues paint-ed in primary colors on the exposed ceiling beams in the bedroom. See how much you can glean from one old luggage label?*

25 80 90 25		20 40
65 3 65 15		40 100
5 85 90		
5 55 85		

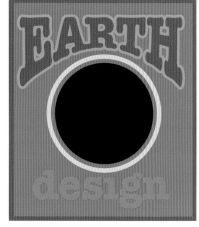

VARIATION

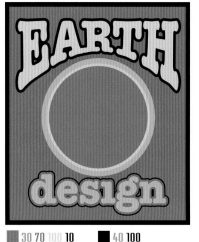

30 70 100 10		40 100
10 85 50 15		
7 25 55		
35 30 15		

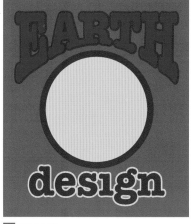

100 70 10
100 100 40
25 100
70 100 100

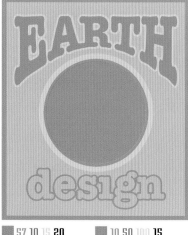

57 10 15 20		10 50 100 15
30 20 50		
20 30 5		
10 20 65		

CUBE IN A CUBE, Andrzej Zarzycki, 1990 *The architect Zarzycki, a native of Poland, created this exploration of the spatial aspects of the cube in form and space. The medium is colored pencil on colored paper. Architects make many such sketches to help themselves visualize complex theories of three-dimensionality, although few such exercises emerge as intrinsically appealing as this one.*

40 65 70 **50** 40 **100**
30 **90** 100
20 **13** 13
40 40 70 **3**

VARIATION

60 **90** 100 **15**
10 40 70
20 60 80
10 10 15

70 20 50 **15**
10 20 100 **7**
40 **75** 37
75 100 100

40 **75** 80
10 35
40 70 **10**
100 50

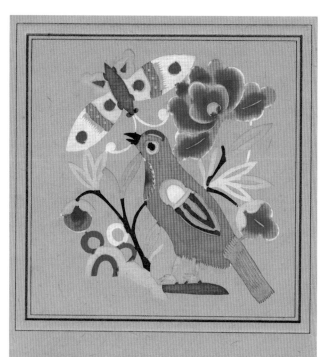

Only a culture with far less of a "time is money" philosophy than our Western one could have produced something as lovingly labor intensive as this. And thank heaven for that! Naturally, these works are produced in quantity for sale, yet that doesn't diminish their purity. The tan mounting paper adds a strong note that significantly alters the overall color direction. Hmm, I wonder if I could lift off the cutout without ripping it?

25 35 45 7	20 100 100 10
7 80	33 10 20
83 85	12 10 20
45 8 47	40 100

VARIATION

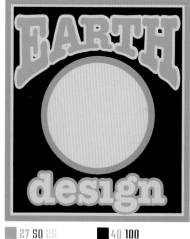

27 50 25	40 100
20 20 20	
30 7 100	
40 50 60	

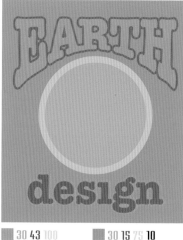

30 43 100	30 15 75 10
40 70 10 20	
17 17 100	
60 13 85	

37 60	55 65 10
45 40 5	
13 25 20 7	
45 27 35 6	

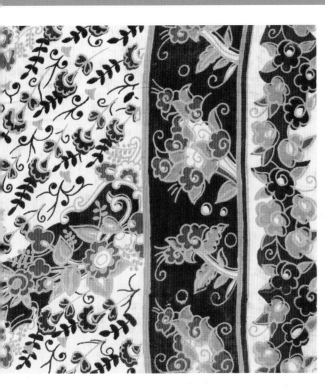

INDIAN FABRIC, 1997 *Our attempts at creating color layouts (below) comparable to this complex fabric design are hardly adequate. At least we've spec'd out the colors for you. A wealth of wondrous color combinations may be found in fabrics from India, Indonesia, Thailand and other exotic places. This example again proves that beautiful color can be found everywhere if we set our eyes to "seeing mode."*

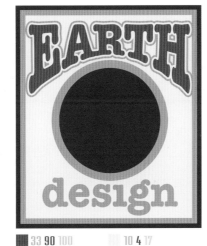

33 90 100 10 4 17
47 40 15 3
53 25 85 7
50 100 100 10

VARIATION

30 75 75 35 100 70 35
70 30 100
37 75 20
100 15

15 65 100
30 50 100
30 95 75
45 100

50 60 65 100 40 10
100 15 20 15
80 5 30
60 40 17

If you want to see some of the most innovative, far-out, sometimes lousy *but always interesting graphic design, check out the rave flyers at your local boutique, record shop, head shop, or wherever else the hip guys 'n' gals in your burg congregate. Much media attention has already been given to rave flyers, those mini-advertisements for musical and performance events, dance clubs and after-hours discos. These flyers often look like an explosion in the Photoshop factory, because every computer trick in the manual is utilized by the artists. Some flyers are designed by seasoned pros in their twenties, but many are produced by rank amateurs. Because of their unruly and undisciplined approach, these unschooled, techy kids, each with a Macintosh (or access to one), are the nemeses of older designers who often resent them for lowering standards, undermining prices and for making a mockery of design principles. The entrepreneurs of these movable blasts, the rave "parties" as they are called, are the P. T. Barnums and the Florenz Ziegfelds of the twenty-first century. They apparently think nothing of spending $10,000 to publish their diminutive propaganda. Though usually "gang run," these four-color, UV-coated flyers are sometimes even die cut in creative shapes, adding to their cost. Partly through ignorance, and partly because of the fly-by-night aspect of raves, designers have no qualms about scanning copyrighted images into their designs. Famous cartoon characters, photos from magazines and other images are all fair game to the scanner's uncritical eye. Perhaps for this reason, few American flyer designers were willing to participate in this book. European artists, however, proved most forthcoming and eager. Regardless of whether you like them or not, when you look at rave designs you are looking at the future.*

Opposite: Collage background design: Martin Woodtli

133

BERNE'S FUNKIEST

BERNE'S FUNKIEST, Büro Destruct, 1997 *Without a doubt, Switzerland's funkiest designer is Lopetz of Büro Destruct. Even the name of the firm suggests a trashing of antiquated design precepts. Lopetz is versatile too, with styles ranging from computo-techno-anarchy to friendly-slick-commercial. The gray used in this example was actually a silver ink. Combining that with white, tan and dark brown is a little bit weird, but perhaps that was Lopetz's intention.*

▨	10 20 **15**
▨	**45**
▨	**40 40 70**
☐	WHITE

VARIATION

▨ 70 10 20	▨ 100 50 20
▨ 35 60 7	☐ WHITE
▨ 35	
▨ 20 100	

▨ 15 100 100	▨ 100
▨ 45 100 100	▨ 40 100
▨ 47 80 10	
▨ 20 35 5	

▨ 7 45	▨ 40 25
▨ 10 30 70	▨ 15 7 7
▨ 30 65 37 45	▨ 67 25 70
▨ 80 30 10	

HEADRILLAS, Büro Destruct, 1997 *I'm not sure what a Headrilla is, but the illustration gives a pretty good idea. The color combination is simple, almost "normal," yet it is bold and effective. Lopetz has chosen an interesting font to tweak (probably one letter at a time) in an unusual way. Somewhere, the ghosts of Giambattista Bodoni and Herb Lubalin are probably sitting around and complaining to one another, "But you can't read this stuff!"*

▨ 27 100 **6**		
■ 100 43 18		
□ WHITE		

VARIATION

▨ 40	▨ 40 100	
■ 100 5 100	■ 40 100	
▨ 40 100	□ WHITE	
▨ 65		

▨ 20 20 20	■ 100 10 50 **10**	
■ 60 30 15 **7**		
▨ 10 100 30		
■ 30 100 40		

▨ 30 85 **7**	▨ 20 40 80	
▨ 10 60		
■ 70 50 10		
■ 40 50 30		

FLYER MANIA, Bastien Aubry/illustrator, 1997 *Here is the book to buy if you want the full story on European flyer design. It was produced by the group Die Gestalten and published by Ullstein Buchverlage GmbH, both in Berlin. The cover is printed in two shades of blue, black and a fluorescent orange. The design captures the gentle humor that tends to permeate even the most severe of European flyer designs.*

VARIATION

100 75		40 75
80 5 10		100 50
65 3 10		40 100
15 5		WHITE

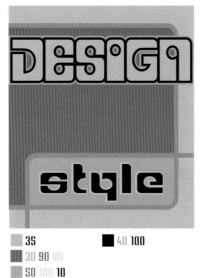

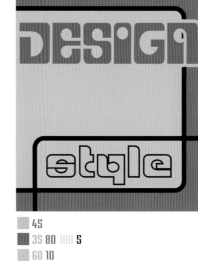

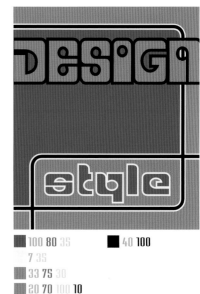

35	40 100
30 90 80	
50 100 10	
65 40 100 7	

45	
35 80 100 5	
60 10	
40 100	

100 80 35	40 100
7 35	
33 75 30	
20 70 100 10	

COOLBONE, Hollywood Records, 1997 *Not really a rave flyer, merely one of those great postcards one picks up free nowadays in racks at the backs of restaurants near the lavatories. The design of this card (a standardization of the flyer concept) is cool and the logo is hot. The color scheme is warm. I like it.*

55 100 9
40 100
WHITE

VARIATION

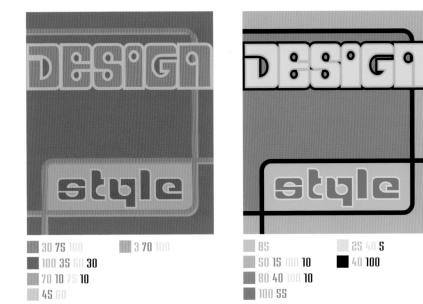

30 75 100 3 70 100
100 35 60 30
70 10 75 10
45 60

85 25 40 5
50 15 100 10 40 100
80 40 100 10
100 55

100 50 WHITE
100 60 50
20 35
65 75

Jochen Thamm produced this flyer for a techno dance club that convenes at the Frankfurt airport. The colors are tasteful and the 3-D computer graphics elegantly restrained.

40 5 30	80 55
100 15 80	40 100
50 30	WHITE
67 75 10 13	

138

7 20 80	50 80 25 15
65 5 40	
30 30 20	
10 20 20 100	

100 5
25 20 7
30 4 100
100 100

10 100 100
100 5 100
10 100
40 100

WASP CLUB, Think Design, 1997 *An orderly designer, Thamm never overlooks basic principles of design in composing his ultra-modern flyers. His background patterns create a feeling of movement and depth which is aided by warm and cool color contrasts. A studiedly awkward bar code plays well against the slick and ethereal 3-D rendered W logo.*

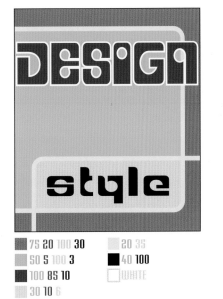

VARIATION

75 20 100 30		20 35	
50 5 100 3		40 100	
100 85 10		WHITE	
30 10 6			

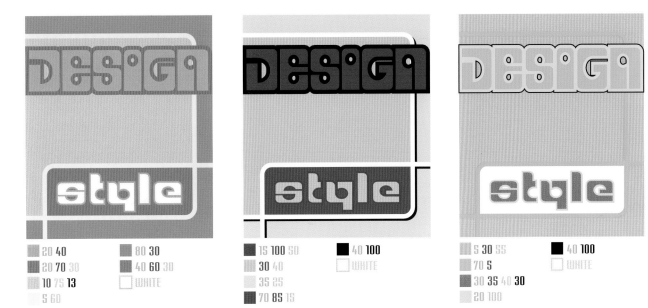

20 40	80 30	15 100 50	40 100
20 70 30	40 60 30	30 40	WHITE
10 75 13	WHITE	35 25	
5 60		70 85 15	

5 30 55	40 100
70 5	WHITE
30 35 40 30	
20 100	

MONKEY LUV, Fleebus, 1998 *Such is the slightly seedy and cut-throat competitive world of raves that designers like the mysterious "Fleebus" are in great demand. His designs, in black and white, are completed months in advance, while his up-to-the-minute color combinations arrive by heavily armed courier at the printer just hours before the presses roll. An arrogant show-off, Fleebus is tolerated by promoters because he's that good.*

30 70 20	5 85 90
30 80	40 100
15 30	WHITE
30 5 10	

VARIATION

60 100 40	WHITE
15 75	
90 65 10	
50 100	

85 35 20
100 35
10 20 100
70 100

100 20	40 40 70
100 20 40	WHITE
40 30 70 25	
5 50 5	

Friday
SAN FRANCISCO DOOMED

SAN FRANCISCO DOOMED, Fleebus, 1998 *We are proud to be able to exhibit another of Fleebus's great designs, which arrived at our printer's office only hours before this book went to press. Fleebus's flying colors have 'em lined up for blocks behind velvet cordons at some of the most exclusive dives in the Bay area. Fleebus agreed to let us show his work only on condition that his true name—Jesus-Maria Alvarez-Strümpfe—not be revealed.*

17 15 100		5 20 45 7	
55		40 100	
5 55 85		WHITE	
20 85 90			

VARIATION

5 50	50 5
15 100 100	
50 100	
10 15 75 25	

50 100 40	20 15 3
40 50 5	
40 60	
30 80 60 15	

100 20	40 100
10 60	
70 40	
80 40 35	

KIOSK, Martin Woodtli, 1997 *Swiss designer Woodtli created these heavy cardboard flyers for Kiosk, an art gallery in Bern, Switzerland. His colors are enhanced by the "show-through" of the gray card stock upon which these flyers were printed. There is no particular theme in Woodtli's colors. Each of the flyers in this group has its own color personality. The old-fashioned-looking logo, in contrast to the ultra-modern layout, acts as the unifying element through the series.*

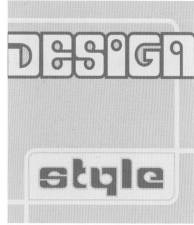

25 17 23
27 5 13
70 30 65 25

VARIATION

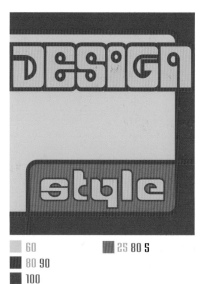

60 25 80 5
80 90
100
40

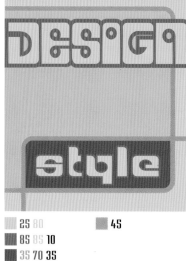

25 80 45
85 85 10
35 70 35
40 25

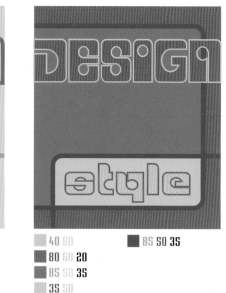

40 60 85 50 35
80 60 20
85 50 35
35 50

KIOSK, Martin Woodtli, 1997 *Here the designer experiments with overprinting of transparent inks. The card is a spinner, reading either end up. The hollow teardrop motifs and the choice of colors remind me of Swiss posters dating from the 1940s. But despite this subconscious environmental bleedthrough effect upon Woodtli's work, the greater influence nowadays is that of the global media village that makes any home anywhere an outlet for trade in the commerce of ideas.*

10 35 70 25 40 60 17
75 20 7 20 15
17 65 90 10 70 7 40 30
70 20 35 50

VARIATION

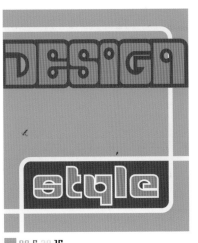

80 5 20 15
80 60
55
75 80 35

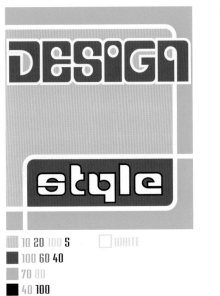

10 20 100 5 WHITE
100 60 40
70 80
40 100

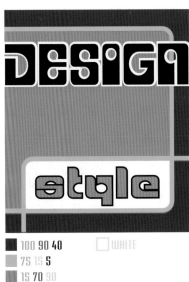

100 90 40 WHITE
75 15 5
15 70 90
40 100

Directory